M000304358

The BOY
NEVADA KILLED

FLOYD LOVELESS
·············· *and the* ··············
JUVENILE CAPITAL PUNISHMENT DEBATE

Janice Oberding

THE
History
PRESS

Published by The History Press
Charleston, SC
www.historypress.net

Copyright © 2017 by Janice Oberding
All rights reserved

First published 2017

Manufactured in the United States

ISBN 9781467137683

Library of Congress Control Number: 2016953493

Notice: The information in this book is true and complete to the best of our knowledge. It is offered without guarantee on the part of the author or The History Press. The author and The History Press disclaim all liability in connection with the use of this book.

All rights reserved. No part of this book may be reproduced or transmitted in any form whatsoever without prior written permission from the publisher except in the case of brief quotations embodied in critical articles and reviews.

For my mom, Bonnie Harper, who has taught me more about love, life and writing than she will ever know.

Contents

Foreword

Janice Oberding is my sister, and I want to tell you how she stumbled on a little-known piece of Nevada's history. We grew up in Reno, Nevada, in a family of readers. The *San Francisco Chronicle* and *Reno Gazette Journal* were left on the breakfast table each morning for all to read. One particular morning, Mama forgot to hide the newspapers. That day's headlines told the lurid details of what would be Reno's most notorious murder. It was a horrifying story that captured the nation's attention. This was in the early '60s, in the days of swift, in-depth reporting, crime scene photos included. Overnight, small-town Reno residents became security conscious, locking doors and checking windows.

Coincidentally, the murder happened on Janice's birthday. That year's birthday celebration was partially overshadowed by fear, but the slumber party was not canceled. After the games, plenty of pizza, cake and ice cream, it was time for bed. That's when the party began. By the light of the full moon, Janice told the murder story. The one all the adults were whispering about. She articulated the crime scene in graphic detail. I'm not sure how we were able to fall asleep that night, but we finally did.

Twenty years later, Janice was writing the story, researching days and writing evenings. She called most nights to share the results of that day's investigation. I was beginning to wonder about her one night when she called later than usual. She had come across an article about some boy from Indiana. She said, "I just couldn't leave the library. He was executed here in Nevada."

Within a few days, all her work on the other murder was stuffed away into a box. She would write about Floyd Burton Loveless, the "boy from

Indiana" who remains the youngest person ever to be executed at the Nevada State Prison.

Janice dedicated decades to the research and travel involved in telling Floyd's story. Between writing and researching, she was tracking people down and scheduling interviews. When she was double-booked, I offered to help.

My first interview was with Oliver Custer, one of Loveless's defense attorneys. The interview took place on the patio at his home. We talked about Floyd Loveless for nearly an hour, and I could see that even after so many years, it still bothered him. "I knew that someday someone would come wanting to know more about this case. That's why I kept the files all these years," he said.

'May I see them?' I asked.

"Certainly," he answered.

He excused himself and went into the house. Moments later, he returned with a large box filled with notes, letters and files. He placed the box on the table, saying, "These are all the files on Loveless."

Forty years had passed. I was literally amazed by the meticulous order of the documents. The contents of the box were overwhelming. I did not expect it. I remember wishing Janice had taken this interview. I took notes and read quickly, but I knew that I could never get all the information in this box. It would have taken weeks, possibly months, to read and comprehend all of it.

Custer's grandchildren were there, urging him to come and play. Knowing it was time to leave, I stood thanking him for taking the time to see me and for allowing me to look through the files.

He stood, saying, "Take them with you. They will help you in your work." I could not believe what I was hearing. Everything that Janice needed was in this box.

Floyd began his life as the third child in a miserable marriage. From there, it didn't get much better.

At the age of fifteen, Floyd Burton Loveless was sitting in the Nevada State Prison, awaiting execution. He spent the next two birthdays at the prison. Those would be his last.

On September 29, 1944, he was executed at the age of seventeen at the Nevada State Prison. Those were not the days of dragging the accused with rope in hand to the nearest tree. But for Floyd Loveless it really wasn't that much different.

By chance, Janice discovered Loveless's short life. I will always believe she was, in some strange way, meant to tell his story. And in this book, she has.

—Diane Carlson Grulke

Acknowledgements

In creating this book, I have been truly blessed with more than my share of encouragement and help. I gratefully acknowledge and thank the following: my one-of-a-kind husband, Bill, whom I love to Pluto (the moon's not far enough) and back; my sister (who wrote the foreword for this book), Diane Carlson Grulke, a wonderfully gifted raconteur and writer; my mother, Bonnie Harper, who showed me the way; my dear and talented friend Deborah Carr Senger, author of *Haunted Bloomington-Normal* (The History Press); my friend Joseph Galata, who was so moved by Floyd Loveless's story that he created and starred in the musical *The Boy in the Gas Chamber*; Mike Loveless, for his many kindnesses, including the use of treasured Loveless family photos; Robert Kay Loveless; Oliver Custer; Thelma Brooks Morgan; Lisa Casper; archivist Toni L. Mendive and the staff of the Northeastern Nevada Museum in Elko; those at the Nevada State Library, Archives and Public Records, and the staff at the Indiana State Library; the Honorable Alvin R. Kacin, for the kindness he showed to two strangers to the Elko County Courthouse; and the staff of the Elko County Courthouse, especially Jenica Maxwell and Mike Judd, who took time to answer our questions on a late Friday afternoon. It's not often that you run into so many helpful and friendly people as I did in Elko while in the process of working on this book. I also wish to thank all those at Arcadia Publishing and The History Press, especially Artie Crisp and Megan Laddusaw.

Introduction

Some are born to pure delight. Some are born to endless night. I never fully appreciated those two lines from William Blake's poem "Auguries of Innocence" until I started researching Floyd Burton Loveless. For if anyone was born to endless night, it was Floyd Loveless.

When I started writing his story, decades had passed since that night in September when the seventeen-year-old was executed. Many of those who had known him were long dead. As I spoke with some, I realized that memories being what they are, much had been forgotten or had been filtered through eyes that saw things very differently in their youth. Some politely refused to discuss Loveless at all.

Early on, I interviewed his stepmother, Dorothy Loveless, who put me in touch with his brother Robert Kay. Kay probably knew Floyd better than anyone else. And fortunately, he readily agreed to speak with me. During our first interview, he asked that I call him Kay. As he talked, he referred to Floyd as Burt. Curious, I asked why he did so. "We called him Burt, short for Burton, for his middle name. None of us ever called him Floyd."

A man well into his sixties, Kay's life had been spent in and out of prison. This had taken its toll. Matter-of-factly, he told of that long-ago day when he and his brothers witnessed their mother's suicide. Whatever sorrow he may have felt at that loss was buried by sixty years of living. Only when he spoke of how young Floyd was "when they killed him" did his voice take on an edge of sadness. When asked about Dale Cline, the boy who accompanied Loveless on his cross-county crime spree, Kay angrily said, "That SOB betrayed Burt....Do you know where he is?"

I didn't. Years would pass before I located him. By that time, it was too late. Cline, according to his obituary, had been dead a week. I would never get the opportunity to interview him. I took a day to beat myself up. If only I had been more diligent. Kay was most likely dead. (My mail was returned and his phone no longer in service.) And now Cline was dead, too. Little did I know that one day I would meet Cline's son, albeit only through social media and phone calls.

My husband, Bill, and I visited Stockwell and Lafayette, Indiana. Our first discovery was that the train no longer came through Stockwell and hadn't for a number of years. The spot where Hazel Loveless ran into an oncoming train was overgrown by grassy weeds, different from how I had imagined it. During our Stockwell sojourn, Bill and I met Thelma Brooks Morgan, a local researcher/historian who remembered Floyd and Robert as children.

"They used to come on Sunday mornings and read the funny papers out on the porch with us," she told us.

After a brief interview, Thelma kindly offered to show us the Fairhaven Cemetery. And so, in search of the Frey family plot, we followed her to the cemetery, which was much larger than we had anticipated, especially on a humid Indiana summer afternoon. We gave up our quest.

I reread Floyd's letters, filled with hope and plans for a future that would never come. Clearly, he held out hope that somehow everything would work out to suit him. At seventeen is it possible to believe otherwise?

In sharp contrast to Floyd's letters were the court papers. There is no hope within these official pages, fuzzy carbon copies on thin, onionskin paper. Officially signed and sealed, they speak of a different era.

The April 18, 1949 issue of *Life* carried a fifteen-page article on Elko County by Roger Butterfield. In the article, Butterfield told about the cattle industry and the size of the county and stated that "one of the peculiarities of Elko County is a marked aversion to capital punishment by due process of law."

Butterfield overlooked Bob White, Josiah and Elizabeth Potts, Sam Mills, Guadalupe Acosta and Floyd Loveless.

There is no doubt that Adolph (Dolph) Berning died at the hands of Floyd Burton Loveless—none whatsoever. Dolph Berning, a husband, father and grandfather, was gone forever because of the senseless actions of a runaway teenage boy. No one could have foreseen such a tragic end for the man who cared so much for others. A man who offered comfort to a grieving mother by crafting a casket for her dead child, Berning was always there to lend a helping hand for a neighbor in need.

Those closest to Floyd Burton Loveless could never have imagined that one day the youngster would die in the Nevada gas chamber. No one could have foreseen the tragedy that would play out when Floyd Burton Loveless encountered Constable Adolph Berning on Victory Highway just outside Carlin. In that one moment, their lives, and those of their loved ones, were forever changed.

Recently, I returned to Indiana with my longtime friend Deborah Carr Senger. A decade had come and gone since I was there last. On another hot, humid Indiana summer day in the Fairhaven Cemetery, Deborah and I went about our task undeterred. Finally, we located the Frey family plot, Floyd's grave and that of his mother, Hazel. In Stockwell, we enjoyed a short visit with local Stockwell historian Thelma Brooks Morgan. Then it was on to Fort Wayne, where we met with Mike Loveless, a half brother of Floyd Burton Loveless. A wonderful storyteller, Mike spent the afternoon with us, regaling us with amusing Loveless family stories.

From Indiana to Nevada, I feel that the circle is now complete. There is nothing more I can learn about the short, sad life of Floyd Burton Loveless.

In telling Floyd's story, I've relied on existing personal letters, court documents, newspaper files and the memories of some who knew him best. What I learned of Dolph Berning was gathered from historic research and an interview that was conducted with his surviving daughter, Peggy Woods, in 1994 by Lisa Seymour of the Northeastern Nevada Museum in Elko, Nevada. Writing this book has been a long journey, a journey that actually started thirty years ago. At times, life and other projects took precedence. Through it all, I knew that this kid's story had to be told. In the telling, I've let the facts speak for themselves. When necessary, I created scenes and dialogue that I thought helped make a complete story. Of course, no one can ever know another's deepest thoughts. Nor can we know the verbatim conversations of people long dead. But after spending more time involved in this project than Floyd Loveless lived, I believe I've been accurate and fair in my portrayals.

As the Twig Is Bent

There is no such thing as justice—in or out of court.
—Clarence Darrow

CARSON CITY, NEVADA

On September 29, 1944, World War II was winding down. The Allies had successfully stormed the beach at Normandy, Paris was liberated and the offensive against the Mariana Islands and Palau had begun.

In Carson City, people went about their lives, all safe in the knowledge they would see tomorrow. At the Nevada State Prison on the south edge of town, it was different, especially for those on death row; their tomorrows were finite. Death dates were set and were seldom broken by commutation.

Seventeen-year-old Floyd Burton Loveless spent his last day on earth praying for a commutation. As the

Nettie Loveless in her kitchen. *Photo courtesy of Mike Loveless.*

clock ticked away the hours, he wrote lengthy letters to his family, apologizing for the trouble he had caused them. While in prison, he had converted to Catholicism. Father Buell was with him in his final hours. The priest had come from Gardnerville to offer solace, guidance and last rites. Floyd's only hope was in the hands of the Nevada Supreme Court. If he allowed his mind to wander, his thoughts went back home to Indiana. If things didn't go well, he would never see his family again and never see his grandmother, whom he loved above all others. The thought brought tears to his eyes.

HAZEL AND RAY

Excitement was in the air. The twentieth century promised to bring sweeping changes. Inventions only dreamed of in the past were fast becoming reality. Before the new century ended, man would fly from one continent to the next, walk on the moon, cure or control many diseases and discover DNA.

As it always did, the dark side of human nature would rise. Progress would not always be used for the betterment of mankind. Terrible wars were waged, each with more devastating weaponry than the last. The atomic bomb would be dropped on Hiroshima before the century reached its halfway point. This would not be terrible enough. Powerful nations would arm themselves with weapons capable of wiping the earth clean.

In Stockwell, Indiana, Assaba and Abie Frey gave little thought to the new century as they welcomed their ninth, and final, child into the world on a hot August morning in 1900. She would be called Hazel Belle.

Little Hazel Belle Frey was less than a month old when Nettie Loveless gave birth to her son Ray Curtis on September 27, 1900. As Nettie Loveless cradled the tiny infant in her arms, she wished for him all the things that mothers want for their children.

In his youth, Leonard Loveless was a telegraph operator. Upon meeting and marrying Nettie May Crick, he wanted something more lucrative—something for their future children. His family had owned grocery stores in the area for decades. So he purchased a store in Stockwell. Together he and Nettie put in long hours for every dollar they earned. There were light moments, too. It was said that Leonard could tally a customer's bill faster than, and just as accurately as, any adding machine. His customers jovially tested him on his speed and unfailing accuracy with numbers. Leonard was proud of this ability his entire life. In another

Left: Leonard Loveless in his grocery store. *Photo courtesy of Mike Loveless.*

Right: Leonard and Nettie Loveless in front of the Loveless Grocery Store. *Photo courtesy of Mike Loveless.*

time and place, Leonard Loveless might have been a bank president or professor of computer science. In early twentieth-century Stockwell, he was content to be a well-liked grocer.

Indiana adopted Paul Dressler's song "Along the Banks of the Wabash, Far Away" as the official state song in March 1913. In 1925, the song became a required part of Indiana's school curriculum. Hoosier schoolchildren were familiar with its lyrics.

In the spring of 1914, Indiana used the electric chair for the first time. Forty-year-old convicted wife killer John Chirka earned the distinction of being Indiana's first person to be dispatched by the new apparatus. While their parents marveled at what electricity could do to the condemned, schoolchildren learned about Tippecanoe and Tyler too. Living within a few miles of the Tippecanoe Battlefield, Stockwell schoolchildren learned about the 1811 Battle of Tippecanoe and of its hero, William Henry Harrison, who later became the ninth president of the United States. Naturally, their lessons included the part Indiana played in the Civil War. Hoosiers were proud of the many men their state sent in answer to President Abraham Lincoln's call for volunteers.

17

More recently was the Spanish-American War, which won Cuba its freedom from Spain. Leonard Loveless was a veteran of this war, which lasted but four months. Born in the new century, youngsters like Hazel and Ray had known only peace during their lifetime. This changed on June 28, 1914.

Halfway around the world, Austrian archduke Ferdinand and his wife were assassinated in Sarajevo, the capital of Bosnia and Herzegovina. Repercussions were far-reaching. Three years after the assassinations, the United States declared war on Germany, and a wartime draft was enacted. Ray Loveless was called up and stationed in Texas, where he trained as a bugler. He wouldn't witness the devastation being played out on the

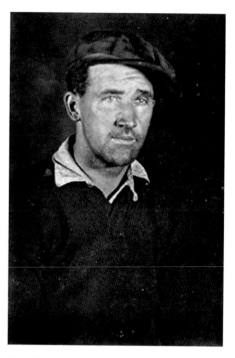

Ray Curtis Loveless as a young man. *Photo courtesy of Mike Loveless.*

other side of the world. Over 1,400 young Indiana men would lose their lives fighting in this war. This, then, was the new century. For the first time, deadlier weapons like tanks, airplanes and poisonous gas would be used in warfare. It would be called the war to end all wars. It wasn't.

With the Great War over, those who had fought in distant places came home as heroes. Settling into lives forever changed, they looked toward futures also altered. Men like Hazel's brothers Elmer and Harry served much closer to home. At the war's end, they would return home honorably discharged. Some would never return. They would spend eternity in distant graves in a strange land far from homes and loved ones.

At nineteen, Ray Loveless fit neither category. According to Stockwell gossip, his short hitch in the army ended with his being dishonorably discharged. Ray, they whispered, was involved in a bloody barroom brawl that left one man dead. It was just another reason to fear Loveless, who had the reputation as a burglar and a bully.

Surely Hazel Frey knew Ray Loveless's reputation. She may have found this intriguing and romanticized that her love would change him.

On August 5, 1920, two days before Hazel's twentieth birthday, Indiana executed its youngest person, eighteen-year-old William Ray. Ray had killed a man during a robbery. Hazel would be long dead when the state again electrocuted an eighteen-year-old, James Swan, for murder.

In an era when girls aimed for marriage, children and little else, Hazel had few options. If she didn't get married, what would she do? No matter what townspeople said about Ray, she wanted to be his wife. They were twenty-two when they drove to nearby Lafayette and married in a civil ceremony that neither of their families attended.

Early in life, Hazel had learned to wait her turn. The youngest of eight brothers and sisters, she had little choice. Ray was different. He'd been spoiled, some said, by an adoring mother and easygoing father.

Ray and Hazel's marriage was doomed from the start. Parenthood only made it worse. The spring of 1926 came and went in a flurry of rainstorms and tornadoes that roared through Indiana, devastating everything in their paths. Safe from the rising banks of the Wabash, the little town of Stockwell was considered fortunate to receive rain without the terrible effects of the tornadoes. With August came heavy rains that seemed to never let up. Fort Wayne received nearly five inches of rain in a day. If this was worrisome,

Leonard and Nettie Loveless in a professional studio photo. *Photo courtesy of Mike Loveless.*

Floyd and Robert Kay Loveless on their tricycles. *Photo courtesy of Robert Kay Loveless.*

money was not. Ray provided for them by working at a nearby ice cream store. But there was his quick temper. Whenever it flared, he lashed out and found himself without a job. Even in these times, there was always another job. And if there wasn't, they would still eat. His parents would see to that. She and Ray fought bitterly, but she adored the elder Lovelesses and got along well with them.

In the early morning hours of November 2, 1926, Hazel and Ray's third child, Floyd Burton Loveless, was born. Much to his mother's delight, everyone who gazed at the dark-haired baby agreed that he was the spitting image of her. Baby Floyd was barely one year old when his maternal grandmother, Abbie Frey, died. Hazel was heartbroken.

HAZEL

In June 1930, farmland was losing value by the day. Once secure jobs vanished as factories and mills closed. The country was in the midst of the Great Depression. On her last day on earth, June 15, Hazel Loveless was surrounded by hopelessness. Never had she felt so trapped. Voluminous gray clouds that had loomed overhead most of the morning finally broke open, spilling rain throughout the day. She didn't have far to walk. Every Sunday, she, Ray and the boys had dinner at his parents' home just across the tracks. Her mother-in-law, Nettie, was probably busy with her kitchen chores as Hazel gathered her sons and started out. She walked quickly, pulling the three youngsters along as they tried their best to keep up with her purposeful strides. At the Main Street railroad crossing, she stopped and listened. There it was—freedom. The southbound Big Four freight train was racing toward them.

Suddenly, she let go of the little boys' hands and admonished them, "You stay here!"

Then without so much as a backward glance, she ran into the path of the oncoming train. The train slammed into her and continued on its journey. As their mother was tossed into the air, the boys screamed in terror. It was half past six in the evening, dinnertime at the Loveless home. Hazel died even as the ambulance whisked her broken body toward Home Hospital in Lafayette.

Hazel Belle Loveless's death left unanswered questions. Accidental death was the finding of the acting Tippecanoe County coroner. Yet

Hazel Loveless in front of the Loveless home with her three sons. Floyd Loveless is on the right. *Photo courtesy of Robert Kay Loveless.*

The Loveless home as it appears today. *Photo by Bill Oberding*

The spot where Hazel Loveless died, as it looks today. *Photo by Bill Oberding.*

many of those who had grown up with Hazel and Ray believed differently. Gossips said that she had committed suicide as a means of escaping an unhappy marriage and the responsibilities of raising three children. There was also the possibility that she was pregnant with a fourth child and unable to cope with that eventuality.

Whether or not she took her own life, her death would have a devastating effect on the lives of her two younger sons. More than fifty years had passed when Robert Kay Loveless was asked if he believed that his and his brothers' lives would have turned out differently had their mother lived. He answered without hesitation, "Yes."

Did he believe her death was a suicide? Again, he answered, "Yes."

Hazel's funeral was held at the same church she had worshipped in as a child. At nearby Fairhaven Cemetery, mourners remembered that only a few years ago, they had come to Mulberry to bury Hazel's mother, Abbie Frey. In their sorrow, they never would have thought that the baby would be the first of them to go. On this day, they stood on the grassy slope and bid Hazel Belle goodbye.

Ray Loveless looked at his small sons, the hot Indiana sun bearing down on them. Left alone with three kids, what would he do? Kindly friends and relatives patted the Loveless boys on their heads. Whatever thoughts they may have held, none dared whisper suicide here. It was a terrible accident, and that was that.

Three months after his sister was laid to rest, John Frey appeared in the Tippecanoe County Circuit Court as guardian of her three minor children. The Frey family heirs owned several acres of land in and around Stockwell. Indiana was as deep in the midst of depression as the rest of the country; a $6,000 mortgage, plus interest, was well past due on the lands. Rents on

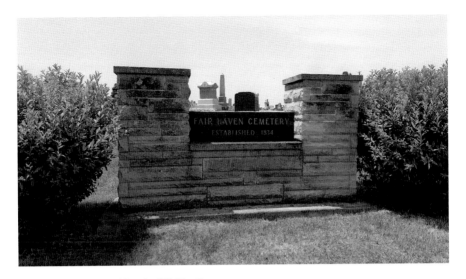

Fairhaven Cemetery. *Photo by Bill Oberding*

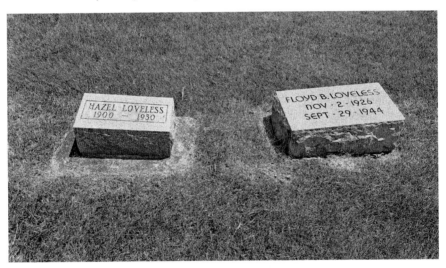

Hazel Loveless's and Floyd Loveless's graves. *Photo by Bill Oberding*

the lands barely paid the interest and taxes. Like so many other Indiana landowners, the Freys were no longer able to make the payments. They hoped to sell before the bank foreclosed on the land their father had worked so hard to own.

The Loveless boys stood to inherit their mother's share. In order to sell, they needed a legal guardian. A year later, the deal was struck, their interests were sold and each boy received $25.21 after expenses; it was

a lot of money in the brother-can-you-spare-a-dime era of the Great Depression. Still feeling guardian-like, Frey suggested the court put each boy's money in a savings bank or trust company in the county until he reached the age of twenty-one. The court agreed.

Frey had done the best he could by his nephews. Now his job was done. He had agreed to be their guardian only long enough to oversee their interests in the sale of the land. The land was sold, and the boys were on their own.

By 1933, unemployment had reached 25 percent. Indiana was still largely agricultural. As prices for agricultural products tumbled, poverty spread across the state. Small towns like Stockwell were hit especially hard. With the buying power of approximately $1,213.72 in today's dollars, that $75.63 the boys had in the bank would come in handy for buying groceries and paying bills.

Ray Loveless and his mother, Nettie Loveless, with a chicken. *Photo courtesy of Mike Loveless.*

There was also the growing fear of bank closures. The money could be lost forever. At Ray Loveless's urging, John Frey petitioned the court to release the money so that "your petitioner have and use the same to provide necessities for said minor children."

The court agreed.

ANOTHER CHANCE

Ray remarried two years after Hazel's death. He needed a wife, and his boys needed a mother. While the new Mrs. Loveless treated her stepsons well, she and her spouse were not happy in the marriage. The ink on their divorce decree had hardly dried when Ray's eyes fell on the much younger

Dorothy Fickle. After the briefest of courtships, she became the third Mrs. Ray Loveless.

Unlike his two previous marriages, this was a happy union that would last the rest of their lives. As happy as she made Ray, Dorothy and her stepsons didn't always get along. This was especially true of Floyd.

Some said it was because Floyd looked like his mother. Others said it was because he was spoiled by his grandmother Nettie and aunt Ruby. No one could deny that Floyd was a budding thief, just as his father had been. But his stepmother probably didn't think of that when ticking off the child's faults. According to Nettie, the stepmother simply didn't like Floyd. The feelings were mutual; he avoided her whenever he could.

By some accounts, Floyd looked up to his brother Kay, who at ten seemed worldly and grown up. When the boys started getting into trouble, most of the family agreed that it was Kay's idea. The stealing, the burglarizing of neighbors' farmhouses and the shoplifting at every store in town were nothing more than Kay's leading Floyd astray. Only Dorothy disagreed. Floyd, she insisted, was the strong-willed one. Leave it to him to talk his brother Kay into their childish crime sprees. And leave it to the family to blame Kay.

At nine and ten years of age, the two younger Loveless sons had reputations as a couple of mischievous youngsters who weren't receiving

Young Dorothy Fickle Loveless in a flapper-style hat. *Photo courtesy Mike Loveless.*

Dorothy Fickle Loveless as a young woman. *Photo courtesy of Mike Loveless.*

the proper guidance from the adults in their lives. Much of what they did was chalked up to their being motherless. As young as they were, the boys took full advantage of the community's pity. They attended the Methodist church every Sunday morning. The lessons being dispensed there were of no interest to them. They had discovered an easy way to get what they wanted. And it didn't include do unto others. As they grew older, the Loveless boys' crimes would become more blatant. By then, the town's pity was spent.

By the summer of 1938, area farmers had enough of the Loveless brothers breaking into their farmhouses and stealing whatever they could get their hands on. There was nothing to do but file complaints against the boys. The judge was kindly; the youngsters caught a break when he decided jail was not the place for them. These youngsters, he reasoned, might benefit from living with their aunt Ruby rather than their father and his wife.

And so they moved into the two-room cottage with their aunt. But she couldn't keep the boys out of trouble any better than their father could. She finally gave up and moved away, leaving them behind. Their mother was dead. Their father had a new family and had all but abandoned them. Without adult supervision, they spent their nights burglarizing homes in Lafayette. In their bravado, the boys started hopping freight trains and playing with guns.

"The apple doesn't fall too far from the tree," people told each other knowingly.

There was barely enough money to live on, let alone buy the things on display at Horwitz's Variety Store. It was hard enough just to scrounge up a few pennies for Floyd to pay for his soda pop and his candy, let alone the gleaming pocket watch that caught his eye as he glanced at the display of candy.

Floyd Loveless with the family dog.
Photo courtesy of Robert Kay Loveless.

While he pretended to decide which candy he would buy, Floyd fumbled for coins and then quickly grabbed a candy bar and shoved it into his pocket. He was thirteen; he might have gotten away with his crime. He didn't.

The clerk saw him. "Put that candy back where you found it, young man. And then you may leave the store."

His face flushed red with humiliation, he flung the candy down. At least she didn't call the police on him. It was better than reform school and jail. Floyd ran from the store, cursing her and his own ignorance. Kay had warned him if he was going to do things against the law he had better wise up, quick. With the memory of the angry storekeeper fresh in his mind, Floyd decided that now might be a good time for wising up.

Chapter 2

1942

NIGHTS IN LAFAYETTE

On December 7, 1941, the Japanese attacked Pearl Harbor, bringing the United States into another war. On the homefront, the war effort took center stage and rationing was the order of the day. Sugar, flour, gasoline, meat, butter—everything was needed to fight the war. Shortages weren't the only effect of the war. According to the National Probation Association 1943 Yearbook, the first two years of World War II saw a surge in juvenile delinquency. In May 1942, a convention that addressed the issues of juvenile delinquency was held in New Orleans. Some parts of the country were beginning to take a different, more enlightened, approach toward probation and youthful offenders.

THE CAT BURGLAR

In April 1942, Floyd thought of nothing but the ring with the large amber stone. Flush with cash, he stopped at Horwitz's. Slipping the ring onto his middle finger, he pulled a bill from his pocket and placed it on the counter. While the cashier made change, he grabbed a ladies' watch from the display

and stuffed it into his pocket. But there was something more important on his mind. The idea of being shipped overseas sounded exciting. The radio carried news of the war every day. Men were needed to fight; his older friends and cousins were enlisting. He wanted to join the armed forces, too. Girls were impressed by a fellow in a uniform, and just think of the strange lands he'd see as a sailor. He'd be sixteen in six months, and he could fight as well as the next guy. He took all the tests and passed. He was ready to join the navy. He only needed his dad's OK.

To his surprise, his father refused to sign. Ray didn't want his son going off to war. Too many boys were already getting killed. Floyd wouldn't be one of them. He would have to wait until he was old enough to see action. Hopefully, he would change his mind before that time came. Floyd was crushed. Neither he nor his father would ever forget this night.

Police called him the cat burglar. His crime spree began in May 1942 in the Oakland Hill area of Lafayette. Men working the night shift nervously checked their doors and windows before heading off to work. For the next nine hours, they and their wives would worry lest the prowler choose to break into their homes. The burglar struck after midnight and always when a woman was home alone. The crimes turned violent on June 20. Kids his age were home and in bed. Floyd was in Lafayette looking for something to steal. As long as it added to his and Kay's cache of stolen goods, he was happy.

In his later confession, Floyd stated:

On June 19, 1942 I came to Lafayette and was on my way home at about 1 A.M. on June 20, 1942. I walked out on Kossuth Street in Lafayette when it occurred to me that I could make some easy money by getting into a house. A few houses west of Mrs. Soller's residence at 2215 Kossuth Street, I took two quart milk bottles from the porch. In my pocket I had a skeleton key which I had found on my brother's place. I was getting pretty close to Main Street and Kossuth when I spotted a house which I later learned was Mrs. Soller's residence, 2215 Kossuth Street. I walked over to the side door of this house and tried the door. I then unlocked the door with the skeleton key I had and left this door open. I went into the house and sat down on the davenport. I got up after about ten minutes, looked into a room at the end of the hall and I noticed a woman asleep in this room. I then looked into the other room and saw another woman sleeping in that room. I then turned the light on in that room and the woman woke up and I turned the light off and stepped

out in the hall. I had a handkerchief over the lower part of my face and covered part of my nose. I fixed this handkerchief while I was sitting on the davenport. This lady then stepped out of her bedroom and then I hit her with one of the milk bottles I had.

She staggered and the other woman came out. The lights were turned on by someone and the woman whom I hit with the bottle asked me what I wanted and I said I wanted some money. This woman went into her room, took a pocketbook and gave me two twenty dollar bills. I took the money and asked her if that is all she had and she said yes. I then told them to get back into their rooms and then I left through the side door by which I entered. Alongside the filling station on Main Street at Kossuth I threw the second milk bottle I had over a fence and it hit some tracks and it busted. I then walked out on Main Street and caught a ride home near Huttons. Robert Kay Loveless my brother borrowed twenty dollars of this money and I spent the other twenty on shows and I don't know what all. When I got home that night I told Kay all about what happened and he knew that the twenty he borrowed from me was stolen.

Shortly after the cat burglar ran into the night, the team assigned to catch him arrived at the Soller home. When describing her sister-in-law's assailant, Emma Soller recalled a slight young man about five feet, ten inches tall who wore a blue-striped shirt, denim trousers and work shoes. Her description matched that of the other victims. Police officers were certain that this was the work of the cat burglar.

On the slim chance the prowler might be among those enjoying Saturday afternoon at the courthouse square, every available officer was assigned to watch the crowd for someone matching the cat burglar's description: a skinny young man in a striped shirt and blue trousers.

Jennie Horwitz stared at the teenager across the counter from her. Here he was in her shop trying to sell the very watch he'd stolen from her three weeks ago. She glanced out the window to see another boy peering in at her. When he realized she was looking at him, he turned away. He was cross-eyed—she would remember to tell the police that.

"You stole this from me," she said, snatching the watch from him.

He should have known better. Maybe he could grab it from her. He was bigger and stronger. "Forget it!" He snarled, racing for the door. She watched the two teenagers jump on their bicycles and speed away.

In his confession, Loveless told of that event:

On or about June 2, 1942 I went to the Horwitz Store at 828 Main St, Lafayette and purchased a ring for $1.10 and while Mrs. Horwitz was writing a receipt, I stole a ladies Elgin pocket watch. A few days later I went back to this store to sell this same watch back to Mrs. Horwitz but she recognized the watch, grabbed it and said it was a stolen watch and then I left.

Jennie Horwitz called the police. "This young man just tried to sell me the same watch he stole from me about three weeks ago. I tried to keep him here while I phoned you. But he got suspicious and ran out." She stammered nervously.

When investigators arrived at Horwitz's Main Street store, they found the shopkeeper calm. "If that doesn't beat all, that boy was trying to sell my stolen watch back to me!"

"How do you know he was the same person who stole the watch?" an investigator asked.

"I'm not likely to forget him," she said.

"Can you describe him?"

She closed her eyes and thought a moment. "He's got a thin face and a dimple in his chin. He's one of those boys that have a sullen look about them and a very smart mouth. Besides," she smiled, "he was still wearing that ring I sold him a while back."

Holding his excitement in check, the investigator asked. "What ring?"

"One of those cheap costume rings. A woman's ring like those over in the case." She nodded toward the display case. "It was a dollar ring with a big amber stone."

He studied the garish rings sparkling in the case. "Mrs. Horwitz, that was the cat burglar."

"What?" She gasped. "Which one of them?"

"I beg your pardon?" he asked.

"There were two of them. The boy with the ring that came in here and the older, cross-eyed boy that waited outside by the bicycles."

"What color were the bicycles?"

"They were both red."

"Did you notice which way they went?"

"North."

THE WRONG DIRECTION

Floyd was back in Lafayette and looking for a car to steal. The best place to find one was the Fowler Hotel on Ferry Street. On this night, luck was with him. There in front of the hotel was a shiny Studebaker sedan.

In his confession of July 6, 1942, Floyd Loveless said:

I stopped and noticed that the car had keys in it and I got in and I pushed on the horn accidentally and got out quick, thinking someone may have heard it. I stood nearby for a while and when nobody came, I started the car up and drove out on State Road 25....I stopped and looked over the things that were in the car. I piled some of the things which were in the back of the car into the front and I began throwing stuff out of this car before I got to Logansport and after I had passed thru [sic] Logansport. One large trunk, small medicine bag, one suit case I threw out near a golf course on Road No.1 near Waynedale, Indiana. I did not keep anything that I found in this car. There was no one with me when I stole this car or while I was riding in it. I drove the car to Waynedale, Indiana where my father lives but when I got there I decided I did not want to stop to see him and I drove back.

Further into the confession he told of his decision to break and enter a nearby home:

I came to Lafayette about 2 o'clock in the afternoon. I got a ride on 52 near the Stockwell Road with a worker from the Aluminum Company. I went to a show and then I went to the Columbian Park. I was starting home about midnight June 30 1942 and I passed a house which I later learned to be the residence of Mr. and Mrs. Knoth, 417 Park Avenue, Lafayette. It was all lit up and I looked through the front window and saw a woman ironing in the kitchen which was located in the back of the house. I decided to get into this house.

Alone in the bungalow at 417 Park Avenue, Mrs. Knoth bent over the ironing board, unaware that someone was watching her. It was hot, and her screened windows were open so the house would be cool when her husband returned from his overnight shift. Then they could sleep a few hours before the house warmed up all over again. She absently slid the iron back and forth across a shirt that hung on the ironing board. Finished, she stood the iron on its end and went to another room for a clothes hanger. Now, Floyd

thought, was his chance. Mrs. Knoth returned to the kitchen, slipped the shirt on a hanger and picked up another one. Placing it across the ironing board, she hummed softly to herself.

I went up on the porch and took a little chair and I went around to the side window of this house and put it under the window. I pulled the nails out which had held the screen in place. Took the window screen off and sat [sic] it down. The window was already open. The woman was still ironing. I climbed in through this window and walked into the bedroom and looked around.

With his lower face covered with a handkerchief, he searched the room for something worth stealing; he found a man's wristwatch first and then a loaded revolver. This might come in handy, he thought. He smiled and sat down on the bed. He could wait. Minutes passed. Finally, she came into the bedroom

"Who are you?" she demanded. "How did you get in here?"

He jumped up, pressing the gun against her. "Take off your clothes!"

"No. Oh please no," she sobbed. "Please don't do this. My husband will be home any minute."

It was a lie; he knew her husband worked all night. Holding the gun firmly in his left hand, he raped the young wife, oblivious to her pleas. His face might have been partially covered, but she would remember what he wore: a blue-striped shirt and blue-green trousers.

After I was through this woman started hollering and I ran out of the house through the front door and down Park Avenue towards Main Street. I heard this woman hollering about four blocks away....In the 2500 block on Main Street I threw the flashlight into a yard....I told my brother Robert Kay Loveless what happened and I gave him the watch I stole to keep for me. Later on he told me that he lost this watch...

I had the gun in Junior Loveless's car. He is my brother. On the night of July 1, 1942 Junior and I had a couple of girls out riding in his car and after that I missed the gun. I don't know what happened to it. We must have lost it. The last time I saw it, it was on the back seat of my brother's car.

Officers found Mrs. Knoth sobbing in her kitchen. As she described her assailant, they realized this was the work of the cat burglar and that his MO had changed. Now that he was a rapist, they would work round the clock to catch him.

Floyd Loveless with an unidentified girl. *Photo courtesy of Robert Kay Loveless.*

With World War II in full swing, the Fourth of July 1942 was a day of families and patriotic celebrations. Floyd was at Columbian Park in Lafayette for the fireworks. He wandered through the park and watched, enthralled as fathers hoisted children overhead so that they too might catch a glimpse of the sparkling sky show. While the little ones giggled with delight, their mothers smiled with pride.

Everywhere Floyd looked, someone was eating. The aroma of barbecuing meat hung in the air, reminding him that he hadn't eaten since breakfast. He stopped at a hot dog stand and dug a nickel from his trouser pocket. Hungrily, he shoved the proffered hot dog into his mouth. Too soon, the fireworks were over. Once again, the night sky was dark. Families gathered up their blankets and picnic baskets and headed for their homes. As Floyd walked on South Street, a Ford V8 coupe caught his eye. He made certain that he was alone on the street and then opened the driver's door. The keys were in the ignition. "I got in and started the car, drove to the Soldier's Home and back and left the car at Maple Point near Lafayette about 1 o'clock on the morning of July 5, 1942."

Police questioned farmers in the area about two boys on red bikes. They caught a break when a farmer in Monroe suggested they check out the Loveless brothers. "Those two are in one kind of trouble after another," he told them.

With a name in mind, police officers searched the juvenile court records. There they found files on Robert Kay Loveless. There was also information on Loveless's fifteen-year-old brother, Floyd. Described as "a pimply, arrogant, emotionless incorrigible who rebels at discipline and manifests a

34

deep-seated anti-social attitude," Floyd Loveless was, according the report, the strong-minded brother who called the shots. All they had to do was locate the two brothers.

An informant told them the boys were living on their own in a shack near Monroe. Before they could comb the area, police received a phone call from a pawn shop. Someone was in the shop trying to sell a stolen watch. Officers stealthily converged on the shop and followed the boy back to his and his brother's hideout.

Within minutes, the cat burglar was in custody.

At the Indiana State Police headquarters, Floyd Loveless admitted to breaking into more homes than the police were aware of. Under questioning, he also confessed to the rape of Mrs. Knoth and the attack on Mrs. Soller.

The victim Mrs. Knoth couldn't positively identify Floyd. The clothing had already been identified as belonging to Floyd. It looked like what the assailant had worn, but she couldn't be certain.

Floyd confessed but was not charged with, or convicted of, the rape. His confession to the rape of Mrs. Knoth would later be read in open court and used in determining whether or not to commute his death sentence to life in prison.

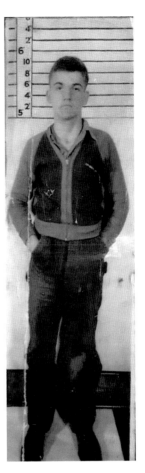

Floyd Loveless cat burglar lineup photo. *Photo courtesy Robert Kay Loveless.*

JULY 15, 1942

The adults in Floyd's life had failed to keep him out of trouble. After his arrest, the duty to set the boy on the right path fell to the State of Indiana. The state was up to the challenge; for eighty years, it had sent its incorrigible boys to Plainfield Boys' Home. Many of them turned their lives around, acquired vocational skills and became productive citizens.

Floyd was four months from his sixteenth birthday and charged with burglary. None of his adult relatives attended his hearing in juvenile court. A

smirk crossed his face when Judge W. Lynn Parkinson asked if any member of his family was present.

"No," he answered.

But Kay was also in court, awaiting sentencing for having received the stolen goods from Floyd. Years later, Kay would remember this day as the last time the two brothers ever saw each other.

Floyd listened to the charge of first-degree robbery and calmly pleaded guilty. They couldn't send him to prison or a reformatory, he was only fifteen.

Judge Parkinson glared at Floyd. "I can exercise my powers only within their prescribed limits. I hereby sentence you to the Indiana Boys' School until you become of age," he said.

So there it was. He would be at the school until he was twenty-one years old. Five years at the Indiana Boys' School in Plainfield some sixty miles away—this must have seemed like forever to someone his age. He promised his grandmother to obey the rules and to stay put. Keeping that promise proved more difficult than he imagined.

PLAINFIELD

He arrived at the Plainfield Boys School in the summer of 1942. Situated on 1,300 acres, the school was a working farm that produced wheat, oat and corn crops. This wasn't a tony place reserved for the sons of wealthy men. Those who came here were from impoverished and broken homes, homes in which physical and emotional abuse were meted out. About five hundred boys were usually housed here. Many hadn't even attended school regularly. They would receive their education in this place. In addition to a curriculum that followed that of the public schools, Plainfield offered vocational training in one of two fields: trades and industry or agriculture. With the war effort, there was little money for needed repairs and staff. Because it was wartime, many of these boys wanted to enlist in the armed forces, and Plainfield offered a national defense training program and military training.

The annual report of William L. Howard, director of education, for the fiscal year ending June 30, 1941, lists the vocational skills that were offered:

In the Trades and Industry field he may choose from; electrical work, baking, woodworking, laundry, shoe repair, printing, tailoring, barbering, cooking, painting, cement and bricklaying and plumbing,

In the field of Agriculture he may choose gardening, greenhouse, orcharding, poultry, livestock, dairying, farm shop and general farming.

Boys who disobeyed the rules and regulations were punished. The punishment depended on the severity of the infraction. Rules and regulations were new concepts for Floyd. Later, as he fought to stay out of the Nevada gas chamber, he would say that none of the adults in his life had ever reprimanded him. At Plainfield, the boys lived in barracks referred to as cottages. Each cottage was supervised by a husband-and-wife team. Early wake up at 6:00 a.m. and early to bed at 8:00 p.m. was hard for Floyd; he was used to getting up when he wanted to and roaming the streets of Lafayette late at night with no chores and certainly no consequences. Here, the boys were kept busy with household chores, school lessons and vocational training. From Superintendent E.M. Dill's seventy-seventh annual report: "The Indiana Boys' School was organized and is operated for the purpose of re-educating the boy who has not been able to adjust to rules and regulations of society....It means that many of the boy's behavior patterns must be reshaped."

There would be no opportunity to reshape Floyd. He wasn't staying long. Nonetheless, he looked at his options and decided to train as a barber. While training, Floyd befriended Dale Cline, whose birthday fell exactly one month before his did. Kindred spirits, they were assigned to company nine. Living in the same cottage gave them time to talk about the offenses that had brought them to the school. As the days wore on, their braggadocio gave way to complaints about their shared circumstances. They agreed that Plainfield was too strict; this was especially true for Floyd, who wasn't used to adult supervision or intervention. Neither had ever worked as hard as they did at Plainfield. Their stomachs rumbled day and night. When they were finally arrested in Nevada, Dale said of his time at Plainfield, "I was always so hungry."

A sample listing of menus of the time lends credence to this complaint:

Breakfast: Syrup, butter, oatmeal and sugar
Dinner (lunch): Beef and noodles, boiled rice, sauerkraut, grape butter, bread
Supper (dinner): Pork and beans, tomatoes and onions, chocolate pudding, bread and milk

They broke rules but were clever enough to avoid anything that might warrant a whipping. This was the 1940s; corporal punishment was used on anyone who committed a serious enough offense. Hearing someone being whipped was painful.

Five years after Loveless and Cline ran away from the Indiana Boys' School (Plainfield), an incorrigible thirteen-year-old boy by the name of Charles Manson was sent there. Manson would escape from the reformatory several times over the next few years. In the book *Manson in His Own Words* by Charles Manson and Nuel Emmons, Manson describes the terrible cruelties and harsh punishments inflicted on inmates at Plainfield during his time there.

During Floyd's brief stay, several complaints were lodged against the home for its treatment of inmates and lack of qualified psychiatric doctors. None of this mattered to Floyd; he'd decided to escape. When his bravado kicked into high gear, he talked about going on a crime spree that would shame John Dillinger.

Dale Cline was impressed. Floyd knew the score. While the others slept, they plotted their escape. Their chance came on August 15, 1942. There was no going back.

Escaping was easy. They simply walked away. The plan was to go out West to California. Indiana's humid heat bore down on them as they raced along the two-lane dirt road.

"We'll never get to California without a car," Dale moaned, wiping sweat beads from his face.

Floyd laughed. "Course we're gonna get a car. You think we're walking all the way to Fort Wayne?"

They would finance their cross-country trip by robbing and stealing. Once in California, they would be home free; neither of them had given much thought to what they would do once they arrived at their destination. It was all in the getting there.

"You think they miss us yet?" Dale asked

"So what if they do?" Floyd countered. "They still have to catch us."

Floyd was right. Dale nodded in silent agreement.

Getting caught meant going back to a whipping and an unbearable existence neither could endure. With their energy drained, they stopped. The sun had moved toward the west. Certain that at least several minutes had passed since their departure, Floyd turned back and squinted in the direction of the reformatory, a speck in the distance. Slowing their pace, they kept walking. An hour later, they reached the nearby farm town of Mooresville, famous for being the hometown of notorious bank robber John Dillinger.

Every Hoosier knew the story. Dillinger's father moved the family from Indianapolis to Mooresville, thinking the rural farm life would be good for them. But young Dillinger didn't like the farm. He continued getting in and

out of trouble. The big city was where he wanted to be. Eventually, he ended up on the FBI's most wanted list and then dead.

Eight years had passed, and the family still lived in Mooresville. Floyd and Dale were there only to steal a car. They decided on the first house that sat off the road, apart and hidden from other houses. No one was home. They ransacked the house, stealing a gun and what valuables and money they could find. Car keys were hanging on a hook outside the kitchen. The keys fit the ignition of the brand-new Mercury coupe parked outside. Floyd turned the key, and they were on their way.

They drove into Fort Wayne on an empty gas tank. Gas rationing had been voluntary until the spring of 1942, but by August, it was mandatory. Without stamps, no one could buy gas. There were none in the Mercury's glove compartment.

They ditched it and stole a new Buick. Floyd slid behind the steering wheel and eased the car out into traffic. Dale opened the glove compartment and discovered gas rationing stamps—lots of them. They drove through the city until they found a likely neighborhood. Floyd parked the car. And they waited. With darkness, shades were drawn, and house lights were turned on. Houses that stood dark meant one thing: the place was fair game.

Somewhere in Indiana, they stole a U.S. .38 revolver and enriched their haul at each town they stopped in: coins, baubles, a rifle, bullets, folding money and a book of gas rationing stamps. They were set. And they were in a hurry. Taking turns behind the wheel, they ignored the national maximum speed limit of thirty-five miles an hour. The more distance between them and Indiana the better.

By the time they hit Salt Lake City, their cash was gone. After a few burgled homes, they had another bankroll. Somewhere along Lincoln Highway, Floyd pulled the car to the shoulder of the roadway. "Let's get some shut eye." He yawned.

Dale, who had been napping, demanded. "Don't you want to go to California?"

"Sure. But I need some sleep."

"Then let me drive."

"Not while I'm sleeping you won't."

"It seems to me we could—" Dale stopped and listened to the sound of Floyd's breathing. Whatever he intended to say, Floyd wouldn't hear it. He slid down into the seat, his head resting on the window.

And so they slept on the edge of the Bonneville Salt Flats, happily unaware of what fate had in store.

Chapter 3

Welcome to Nevada

ELKO, AUGUST 20, 1942

They woke at daybreak. Shivering in the early morning desert cold, Floyd started the car. When the engine warmed, he pulled the Buick onto the road.

"We'll be in California before you know it."

"I'm hungry—and thirsty," Dale responded.

"Who drank all the soda pop last night?"

Dale ignored him. "Next place we come to, I'm gonna get me something to eat."

Floyd silently floored the gas pedal. He wanted a new life in California, too. Dale pulled the rifle from the backseat and loaded it. "I'm gonna shoot me some crows," he announced, rolling down the passenger-side window. Hanging over the edge, he took aim at birds that flew in the distance.

"I missed that bird back there because of you, Floyd!"

"You missed it 'cause you're a lousy shot."

"You're a lousy driver," Dale countered. "Slow down will you? How else am I gonna hit one?"

"Someone's gonna call the police, you shooting out the window like that!"

"Someone's gonna call the police about you driving faster than victory speed, too."

"You're getting on my nerves."

"Nothing wrong with target practice."

"Quit being such a crybaby," Floyd snarled, easing up on the gas. "Wasn't for me you'd be at Plainfield starving and scared about getting your ass whipped."

"You think you're some kinda big shot don't you? Well, you know what I've been thinking? We ought to split up soon as we get the chance."

"Fine by me," Floyd laughed. "I don't need some crybaby."

"It's a deal then. We'll get another car and go our separate ways."

"Swell. I'm tired of you whining all the time anyway."

"I oughta take a poke at you."

"Not if you know what's good for you."

"Oh, yeah? Just pull over and we'll see about that."

"I'm not about to waste my time."

Floyd eased off the gas pedal until the car was rolling along at less than twenty miles an hour. "If you can't hit a bird now you're the worse shot in the world," he said.

"Think so? Watch this." Dale was halfway out the window. He took aim at the crow. "This time—"

He steadied the rifle and fired. A lifeless bundle of black feathers came twirling to earth. "Did you see? I hit one! I hit one!"

Satisfied that his bullets had found their mark, Dale settled back in the seat. Neither of them spoke for the next several miles.

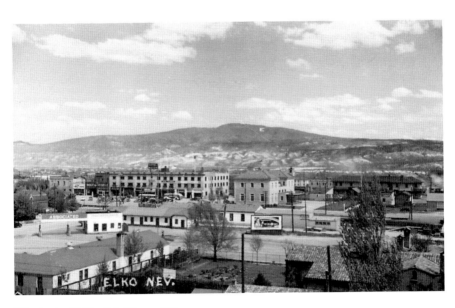

Elko in the 1940s. *U.S. Library of Congress.*

Floyd read the sign at the edge of town, slowing the Buick: Elko County. Here they could go their separate ways. Elko was far larger than Stockwell, though both were small towns. Where Stockwell was made up of farmers, Elko was a community of cattle ranchers, sheep ranchers, miners and cowboys. Founded by the Central Pacific Railroad in 1868, Elko was a relatively new town. Its centennial was still decades away. The first site of the University of Nevada, Elko had subsequently lost the school to the larger, better-known Reno. The first commercial airmail flight in the United States was on Airmail Route Number 5 between Pasco, Washington and Elko. Flying a Swallow biplane, pilot Leon D. Cuddeback made aviation history when he landed in Elko with ten sacks of mail in April 1926. Casino entertainment history was made in Elko when local rancher and hotel/casino owner Newt Crumley set a new standard for gambling establishments in 1941. He built a lounge onto his Commercial Hotel and brought big-name stars like Ted Lewis and Sophie Tucker to town. This changed Nevada gambling forever. Las Vegas would learn from Elko's Newt Crumley. Innovative entertainment wasn't the only thing Elko had. The town also had political clout. Nevada governor Edward P. Carville was a former Elko district attorney and district court judge who was born and raised on a ranch in nearby (Jiggs) Mound Valley. Errol J.L. Taber, chief justice of the Nevada Supreme Court, was a local Elko County man and former district court judge.

Turning off Highway 40, Floyd eased the car to the curb.

"What do you want to do?" Dale asked.

Nevada Supreme Court, circa 1942. *Author's collection.*

FLOYD LOVELESS AND THE JUVENILE CAPITAL PUNISHMENT DEBATE

"I already told you. Soon as I get another car, you can have this one."

Dale nodded and crawled from the Buick. Floyd tucked the revolver in his waistband and stepped onto the sidewalk. On the other side of the railroad tracks, three cowboys were laughing and talking on the street corner. A young couple strode past them arm in arm, no one was paying any attention to Floyd and Dale. "There's a blue coupe over there." Dale pointed.

"And what about those men standing by it? Do I say to them 'Sorry, fellas, I've got to steal this car?'"

The humor was wasted on Dale. "I'm gonna get me something to eat. Give me the keys. You find your own car."

Floyd reached in his pocket. "See you around," he said, tossing the keys to Dale.

"Yeah, see ya," Dale said.

Halfway down the block, he turned around.

"It wouldn't be right not helping you get a car."

"Suit yourself." Floyd shrugged.

They walked up to the Commercial Hotel, peering into car windows as they went.

"Let's go back to the car and look around," Floyd suggested.

"May as well."

Back at the Buick, they noticed a new Studebaker stop in front of the Hesson building. As they watched, the driver slid out of the car and went into a nearby store.

"Betcha he left the keys," Floyd said, "I'll go see."

He crossed the street and crept up to the car. Smiling, he waved to Dale and took one last furtive look at the street. No one was watching. He jumped in the Studebaker and turned the key. From inside his shop, Mr. Hill saw it all—a young hooligan stealing the Horseshoe Ranch's new automobile without a care in the world. As the Studebaker pulled away from the curb, Hill grabbed his hat and started for the sheriff's office. He was still in the office when Deputy Sheriff Guidici came downstairs to get the mail.

As Guidici scooped up several envelopes, jailer Ed Kendrick told him, "Fellow over there by the name of Hill reported a stolen vehicle, a 1942 gray Studebaker, five passenger coupe, stolen right outside Hesson's store. It's been about fifteen minutes. He thinks it may still be in town."

"He does, does he?" Guidici nodded to Hill. "Goicoechea and I'll make a search of town. And you best let Constable Berning know just so in case."

Kendrick wasted no time in calling the constable in Carlin. "Morning, Constable Berning." He said when Berning answered the phone. "We've got

a report of a stolen vehicle here. A gray coupe five passenger Studebaker, license number 26-519."

"I'll get him for you Kendrick," Berning said. "He won't get too far. I'll take the shortcut and head him off when he comes this way."

No stranger to stolen cars, Berning started his old truck and drove up to a narrow spot in the road. With the truck parked so that it partially blocked oncoming traffic, he waited. Traveling salesman Rodney Williams was driving east when he encountered Berning at the intersection of Highway 40.

He stopped his car, and Berning explained he was waiting for a stolen car from Elko. While the two men were talking, the Studebaker drove up. Berning waved the car to a stop.

"That it?" Williams asked. Berning nodded.

"Be seeing you then, Williams."

Williams wished him well and drove on just as a red Buick pulled up alongside the Studebaker. Later, he would identify Floyd as the driver of the Studebaker.

"Everything OK?" the Buick's driver asked.

"Get going," Berning ordered.

Dale nodded and maneuvered the Buick around the truck.

"What's going on, mister?" Floyd called.

"Well you see it's like this," Berning said, opening the passenger door. "You're driving a vehicle that doesn't belong to you, and I'm going to have to take you back, buddy." He slid into the passenger seat. "Turn around and head back to town, buddy."

Williams watched Berning get in the Studebaker and drove on.

"You better get outta this car," Floyd said, pulling the revolver from his waistband.

"I can't do that, son," Berning coaxed. "Now turn around."

"I'm not going back."

Constable Berning, who carried his gun holstered beneath his vest, underestimated the danger. Though Floyd had a gun pointed directly at him, he didn't pull his weapon

"You don't want to do this," Berning said calmly, still trying to talk the boy into going back with him.

Suddenly, Berning lurched for the gun and started hitting Floyd on the head with his fists. Floyd pulled the trigger, grazing Berning in the left shoulder.

Looking back through his rear window, Dale saw the struggle that was taking place in the front seat of the Studebaker and sped away. While they

fought for possession, Floyd fired a second time, hitting Berning in the throat. "I-I'm hurt bad," he gasped. "Get me to a doctor."

Floyd started the Studebaker. "I'm taking you to a doctor, mister. Don't worry." He lied.

After skirting around Berning's truck, he stomped on the gas pedal and sped onto Highway 40.

"Need a doctor—Help me, I'm hurt bad," Berning moaned.

"Yessir. That's where we're going," Floyd assured him.

What was he going to do? He couldn't go back to Plainfield. He had to get away. Get as far away from here as he could. The speedometer needle was pushing fifty, then seventy. He could make it. He could get to California.

"Get me to a doctor," Berning begged. "I can't stand this pain."

But what if...what if...what if this man died, then what? No, Floyd pushed the thought out from his mind. He was past Primeaux station and headed west when the car missed a sharp turn and lurched over a two-foot embankment, crashing onto rocks. "Sorry, mister," he whispered, jumping from the car. "I'll send someone to help you."

He raced to the side of the road. Any minute, he would be free from—a red blur went by. It was the Buick and safety. Once in California, he could forget all this and start over. Dale slammed the Buick's brakes on. In the distance, Louis Stilson and Glade Peterson watched Floyd jump from the Studebaker and wave down the red Buick. Floyd got in the passenger seat, and the Buick sped westward. Curious, Stilson and Peterson went to the abandoned Studebaker. There they found Constable Berning lying face down, his head near the steering wheel and his left arm over the back of the seat. Road foreman S.L. Mendenhall came along about that time; Berning was taken out of the Studebaker, placed in a pickup truck and driven to the Elko General Hospital.

After spending a half hour searching, Deputy Sheriff Guidici and his young deputy Frank Goicoechea found no trace of the stolen car and returned to the sheriff's office. Kendrick met them at the door with the news. "Dolph Berning's been shot out at Primeaux," he gasped. "They're bringing him in to the hospital now."

The two sheriffs sprang into action. In Carlin, they found mechanic Dino Aiazzi working at the Carlin garage. "Constable Berning's been shot. We're gonna need a posse." Aiazzi wiped his hands on his jumpsuit. "Just say the word. Whatever you need to get this man, Sheriff."

"I need to deputize you, Aiazzi."

Aiazzi nodded his assent, and the three of them drove down to the railroad yard office to find Mr. Alexander, special agent officer for the railroad. Everyone in town knew and liked Berning. When told about the shooting, Alexander was happy to help in apprehending the person responsible.

Meanwhile, Dale and Floyd were doing their best to get as far away as possible.

"What was going on back there?" Dale asked after he pulled over to pick up Floyd.

Floyd opened the passenger door. "Nothing," he said, sliding onto the front seat.

"What happened? I saw you and that man fighting in the front seat."

"Just drive dammit, Dale. Just drive."

Dale did as he was told. He wanted to get to California, too. But he also wanted an answer to his question. The Buick's windows were rolled down, and air came roaring in on them.

"What happened?" Dale demanded.

"I had to shoot the sheriff."

"What?"

"You saw us fighting over the gun. I had to shoot him."

Horrified, Dale wished he had never met Floyd Loveless. He kept quiet and weighed his options. Stealing a car was one thing. Shooting someone was another. He knew the score. That was about the worse thing someone could do. This was not what he bargained for when they ran away from Plainfield. Floyd was in real trouble. He would have to get rid of him or else he would be in trouble, too. They rode without speaking; each lost in his own thoughts.

Dale knew what he had to do. "You still got your gun?" he asked.

"Yeah, why?"

"I saw a gun back there a piece by that bush," he lied. "I'll back up and you can jump out and get it."

"Sure thing," Floyd agreed. There was no reason not to. Dale slowed the Buick and backed up a few hundred yards. "It's just over by the bush."

Floyd jumped out and ran for the bush. Every man for himself, thought Dale as threw the car into gear and sped away.

Floyd watched, astonished. He'd been duped. There was nothing to do but roll up his sleeves and start running alongside the highway.

Arthur O'Brien was driving a water truck for the W.W. Clyde Construction Company, which was building the new highway, when he spotted Floyd cut across the field from the old highway onto the new highway. O'Brien noticed the boy seemed nervous as he approached.

"Say kid, do you have the time?" he asked.

"My watch is broken," Floyd responded.

O'Brien smiled. "And what about the other one, on the chain? What time does it have?"

Floyd shook his head and kept walking.

As Floyd did his best to walk his way out of town, Deputy Sheriff Guidici's car sped onto Highway 40 and raced toward Primeaux station. At the service station, the attendant came running to meet them.

"They found Constable Berning out there," she pointed. "Shot!"

Aiazzi jumped from the car, "Did you see anyone?" he demanded.

"He came running and went hitchhiking west," she said.

"What did he look like?"

"He was too far away for me to get a good look at him."

Satisfied that he'd gathered all the information he could, Aiazzi climbed back in the car. Guidici gunned the motor and pulled out onto the highway. They were going to catch the man who shot Dolph Berning if it took them all day and night.

The day was heating up. They rolled down the car windows and let the wind blow in as the car raced down the highway.

"With all this construction going on that truck—look, there it is over there!" Anderson yelled so that he could be heard over the wind.

Guidici slowed the car, pulled up and blocked the truck. "Say there!" He called out the open window. "We're looking for a fellow who shot a constable. You seen anything?"

"Well, sir, I saw this boy. It was the strangest thing…"

"What?" demanded Guidici.

"He came cutting across the field over there looking scared and nervous. I asked him what time he had, and he mumbled something and took off running."

"Which way did he go?" Anderson asked.

"Westward."

"Thanks," Anderson called, as the car rolled away.

The sun was high overhead. Floyd slowed his pace until he was barely walking. All the while, he cursed Dale and thought of the man in the Studebaker begging for a doctor. He had no idea what time it was. Hours must have passed since he shot the man and Dale had left him stranded.

He turned and saw a car coming in the distance. He held out his thumb. They were traveling fast. Would they stop for him? With any luck they might be going to California. The car slowed and lurched to a stop. It was a

Packard with four men in it. They all jumped out. "Put your hands up!" one of them snarled.

Floyd thought about it. His hand crept for his pocket and stopped. Something in the man's eyes said he meant to shoot. Floyd raised his hands.

"Have any trouble with an officer?"

"No, sir," Floyd answered.

"Don't lie to me, young fellow! What do you know about an officer being shot and left alongside the road?" Guidici demanded.

"I did it," Floyd admitted. "

"Is that a fact? Well you just better hope he doesn't die."

They arrested him, handcuffed him and shoved him in the car. He was going back.

"I—never meant to hurt him," Floyd whimpered.

One of the men surprised him by turning from the front seat and asking, "What about the other fella?"

So they knew about Dale. But how?

"He's headed to California."

"Not just yet he's not. That a red sedan he's driving?"

"Yes, sir. A new Buick," Floyd said proudly. "We stole it in Indiana."

Ten miles down the highway, Dale was racing the Buick toward California and freedom. He got as far as Lovelock. Floyd was dropped off at the Humboldt County jail in Winnemucca, and deputies continued their pursuit of Cline. Within an hour, the Buick was surrounded. After a barrage of bullets tore into the car, Cline was unharmed except for a scrape on his nose.

"It wasn't me. It wasn't me who shot him," he screamed as they pulled him from the bullet-ridden car. "I didn't want to get mixed up in a shooting. I let him off—"

Before the night was out, he, too, would be in the Humboldt County jail.

The next editions of the *Elko Daily Free Press* carried headlines, photos and stories. Constable A.H. Berning was in critical condition at the Elko General Hospital. Berning was well thought of and respected in the community. Having been the Carlin constable for over twenty years, he'd had his share of run-ins with outlaws. In 1922, he made national news when it was reported he'd apprehended the killer of Hollywood movie producer William Desmond Taylor. It turned out he hadn't.

There had been a close brush with death in September 1935 when he stopped a vagrant and ordered him to leave town. The man nodded as if in agreement and walked away.

Later in the day, Constable Berning was driving along Railroad Street when he spotted the man again. He stopped his truck and rolled down the window. "I told you to leave town. Come on and get in the truck. I'm taking you to jail." The man pulled a knife. "I'll cut your head off if you come near me," he snarled.

Constable Berning jumped from the truck, swinging his sap. The weapon missed its target, but Berning grabbed for the knife. The man was too fast. He raked the blade across Berning's thumb and into the left side of his neck, missing the jugular by inches.

Berning stepped back from his assailant, pulled his gun and fired three times, hitting him in the chest and thighs. The

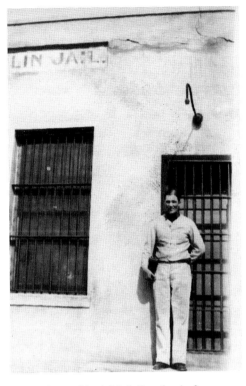

Young Constable Adolph Berning in front of the Carlin jail. *Photo courtesy of Northeastern Nevada Museum.*

stranger dropped dead where he stood. After his fingerprints were sent to the Department of Justice in Washington, D.C, the man's identity was discovered to be one William Dixon, who had been released from a state farm in Greencastle, Indiana, four years earlier.

Constable Berning had arrested a clever teenage horse thief in 1934 without incident. The seventeen-year-old youngster cut the telephone wires to the ranch where he worked so that when he rode off on a stolen horse, there would be time before the theft could be reported. But it was a 1939 incident that would strangely foreshadowed Berning's murder. Three runaway Ohio teens were headed for California in a stolen car. In Elko, the inexperienced driver misjudged a turn, brushing the car's fenders against a parked car. Instead of stopping, he slammed the gas pedal, and raced westward out of town. Unfortunately for the boys, a woman quickly phoned the sheriff to report what she'd just seen. Elko deputies alerted Constable Berning.

Just as he would later do with Loveless, Berning parked his truck and waited for the youthful lawbreakers. The boys were contrite when caught. That story had a very different ending from the one that was being reported across Nevada on this night.

In the Humboldt County jail, Loveless wept as he explained that he hadn't intended to harm the constable. He hadn't realized the man was an officer until it was too late. He wore no uniform, drove no marked car and showed no badge. They were struggling, and the man was hitting him on the head with his fists.

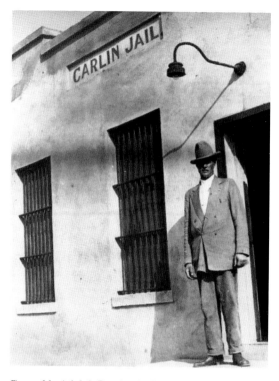

Constable Adolph Berning in front of the Carlin jail. *Photo courtesy of Northeastern Nevada Museum.*

According to Judge L.O. Hawkins in a letter to Nevada governor E.P. Carville on September 18, 1944:

> *I talked at length with Floyd Loveless in a very few hours after he shot Berning and he told me the details of the shooting. At that time he was in the Humboldt County Jail and throughout the approximate one hour I was in the jail talking to him he was sobbing and crying like the little terrified boy he actually was. As a result of that interview I am satisfied Loveless was not then a hardened criminal and that he did not intend to take the life of Constable Berning.*

Early the next morning, Loveless and Cline were transported to the Elko County jail. After fingerprinting and booking, Cline was placed in an upstairs misdemeanor cell and Floyd in a felony cell on the ground floor. Blocks away at the Elko General Hospital, Constable Dolph Berning clung to life. Seven years earlier, his younger sister Mamie had come for a visit, only to be rushed to this same hospital, where she died during emergency surgery. There was no surgery for Berning. Nor was there any hope.

Original Elko General Hospital front door. *Photo courtesy of Northeastern Nevada Museum.*

Top: Original Elko General Hospital photograph. *Courtesy of Northeastern Nevada Museum.*

Floyd was taken upstairs to the sheriff's office. There Sheriff C.A. Harper explained that a statement was not necessary and that anything he might say might be used against him. Harper would later testify that during his confession, Loveless was not compelled or threatened in any way.

Being fifteen, it's doubtful he realized the importance of having an attorney present, much less the severity of the trouble he was in. He didn't have money for an attorney even if he had wanted one. This was how it was done in the decades before the 1966 landmark Supreme Court case *Miranda v. Arizona*, which gave the accused the right to have an attorney present during questioning even if he or she couldn't afford one.

And without counsel, but with District Attorney Clarence Tapscott and S.O. Guidici (one of the officers who apprehended him) looking on, Floyd gave his confession, and it was taken down by a shorthand reporter.

Sheriff Harper asked, "After you got into the car that you stole in Elko, when did you next see Dale?"

"Out on the highway between here and where the constable stopped me," Floyd answered.

"You say the constable stopped you?"

"Yes, sir."

"Where?"

"Carlin."

"How did he stop you?"

"I seen him out there on the road, and I just stopped."

"What happened then?"

"He said that he would have to take me back for being in a car I didn't belong in."

"What time was that?"

"I don't know."

"It was the same day?"

"Yes."

"How long after you stole the car?"

"About [a] half hour or hour."

"After the officer, Mr. Berning, had told you that he had to take you back, what happened then?"

"He got in the car, and I pulled out the gun and said I wouldn't go back with him. He grabbed the gun, and I shot him. The gun got jammed, and we started fighting. And then I pulled the trigger again, and it worked, and I drove off down the road. Stopped the car and got in the Buick."

That same day, Berning died of his injuries at 1:45 a.m., thirty-four hours after being brought to the hospital.

On August 24, 350 friends gathered in Carlin for the funeral of Constable Berning at the Odd Fellows Lodge, where he had been a member. Afterward, people gathered outside the lodge and quietly remembered one of Nevada's oldest peace officers, Constable Berning. A man who was always

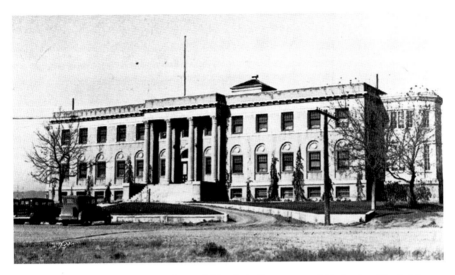

Another view of the original Elko General Hospital. *Photo courtesy of Northeastern Nevada Museum.*

willing to help those in need, A.H. Berning had worked long hours at the Carlin makeshift hospital caring for the sick during the influenza epidemic of 1918. One day not so long ago, he'd put in his day as constable then went home to build a coffin for the child of a family too poor to purchase one. He had spent his spare time working his gold mine in the desert. For relaxation, he played the drums in a band, and every Christmas, he could be counted on to decorate the Carlin Christmas tree.

The town had lost a caring and giving citizen in Constable Berning. It would not soon forget him.

Berning was interred at the Carlin Cemetery.

In explaining the situation Floyd had faced in Elko, his court-appointed attorney Taylor H. Wines wrote to Oliver Custer, who later took an interest in his case, on December 21, 1943: "For several days after being brought back to Elko there was considerable complexity in the District Attorney's office as to how to proceed with the boy and it was finally concluded that a petition should be filed in the Juvenile Dept. of the District Court, at that time I was appointed to represent Floyd at that hearing."

The petition was filed in the Juvenile Department of the district court, alleging Floyd, as a delinquent child, had committed first-degree murder. The petition also asked that he be tried in the district court. Because he was a juvenile, his father and stepmother were also named in the suit and served with summons in Indiana.

Even if they had wanted to, the Lovelesses couldn't drop everything and come to Nevada. There were jobs and other children to take care of. Floyd had really gotten himself in trouble this time, and he was on his own. There was nothing they could do but sign their consent for a hearing of the juvenile proceedings.

While Floyd awaited word on his hearing at the Elko jail, Nevada executed its oldest person. John Kramer, age sixty-one, was escorted to the gas chamber on the morning of August 27, 1942, for murdering his longtime lover, Frances Jones. Reno attorney Oliver Custer appeared at the Board of Pardons and Parole twice, seeking a commutation for Kramer. Two years later, Custer would remember what he learned from those appearances when he fought for Floyd Loveless.

On the September 10, Floyd's hearing was held in the juvenile court division to determine which court had jurisdiction. The question was whether he would be tried as a juvenile or an adult. Ironically, the boys' reformatory, Nevada Industrial School (Nevada Youth Training Center) was located just a few miles from downtown Elko. If the district attorney had his way, Floyd would be going to a far worse place. Judge Dysart had appointed young Elko attorney Taylor Wines to handle Floyd Loveless' case. Not yet thirty, Taylor Wines's roots went as deep in the community as anyone's in the courtroom. Members of his family had lived in the Ruby Valley since the mid-1800s. After finishing law school he'd returned to Elko, where he'd been in private practice just over a year. Busy with other cases the court had assigned him, he would fight to keep his client in the juvenile division and, thus, out of the gas chamber.

Floyd's statement was read.

Happy to have escaped Floyd's trouble, Dale Cline took the stand. And carefully avoiding eye contact with Floyd, he told of their escape from the reformatory and of tricking his former friend out of the Buick.

The defendant was fifteen years old; Taylor Wines didn't want his

Taylor Wines in the 1940s or '50s. *Photo courtesy of Northeastern Nevada Museum.*

case removed from the juvenile division. Wines hadn't had a lot of time to prepare. While discussing other cases involving juveniles, he looked at his notes and then continued speaking: "I have a number of other cases which I haven't here at this time, which I would like to submit later if I may. Subject to the motion to dismiss, which he has made, I would like, if the Court will permit, to put the defendant on the stand and have him testify concerning his life."

"Well, you have the privilege of putting the defendant on the stand if he wants to take the stand at this time," the judge said.

"May I have ten or fifteen minutes to talk?"

"Yes, ten or fifteen, which do you want?"

"Ten minutes will be enough," Wines responded.

He was confident that the facts of the boy's life would sway the decision in his favor. But once they were out of earshot, Floyd refused to testify.

When the hearing resumed, Wines said, "If the court please, we have nothing further to offer."

TRIAL

Extreme justice is often injustice.
—Jean Racine

Elko's first county courthouse was completed the week before Christmas 1869. The two-story brick structure was a courthouse Elko was proud of and a sign of permanency. The county commissioners now had a place in which to conduct business. More importantly was the dispensation of justice that would take place within these walls.

Elko justice was generally swift; Sam Mills found this out the hard way. When he unintentionally blasted his best friend into the hereafter, Mills was tried and sentenced to the gallows. The son of former slaves, Mills was the first person legally hanged in Elko; he would not be the last. Surely, the most notorious people ever tried in the old courthouse were Josiah and Elizabeth Potts, the first and only woman executed by the State of Nevada.

Found guilty of murdering and mutilating Miles Fawcett, the Potts were hanged (behind the present-day courthouse) on June 20, 1890. The execution was unsightly. With black hoods slipped over their heads, the condemned were hanged, one after the other. Josiah was first to go. Next up was his wife,

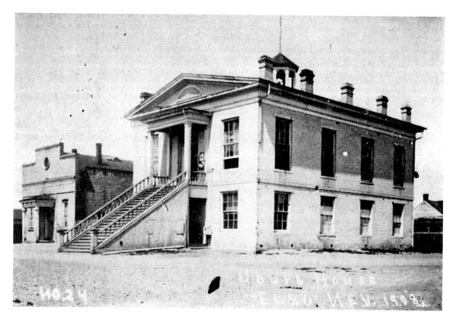

Original Elko County Courthouse, circa 1908. *Photo courtesy of Northeastern Nevada Museum.*

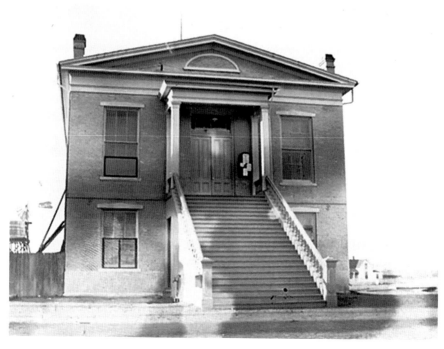

Original Elko County Courthouse. *Photo courtesy of Northeastern Nevada Museum.*

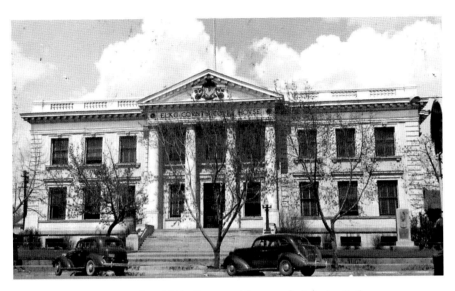

Elko County Courthouse, circa 1940s, from an old postcard. *Author's collection.*

Elizabeth, a corpulent woman in a creamy white frock. The rope couldn't support her weight, and her neck was nearly severed. Witnesses turned away in horror. Mrs. Potts's white dress was covered in blood.

Twenty years after the Pottses' executions, county commissioners decided that Elko County needed a larger, more prestigious courthouse. They hired well-known Watsonville, California architect William H. Weeks to design just such a building. In 1910, the old brick building was demolished, and a Neoclassical-style courthouse was erected at a cost of $150,000 on a nearby site at the corner of Sixth and Idaho Streets.

Elko County gained some notoriety with a case that was tried in the new courthouse on September 18, 1917. District Attorney Edward P. Carville prosecuted Ben E. Kuhl for a murder in Jarbidge Canyon in Northern Elko County. Kuhl, a petty criminal with a long record, had lain in wait for the mail stage bearing thousands of dollars in cash. After killing coach driver Fred Searcy, Kuhl made off with over $3,000. Billed as the West's last stagecoach robbery by newspaper writers, the case was cracked by a bloody palm print that matched Kuhl's. Kuhl admitted to killing Searcy but claimed they had planned the robbery together. The killing, he said, occurred during an argument. After two hours of deliberation, the jury found Kuhl guilty, and District Judge Errol J.L. Taber sentenced him to death. The sentence was appealed and commuted to life. Carville went on to be Nevada's governor and Errol J.L. Taber a Nevada Supreme Court

A blindfolded Lady Justice (one of three) above the front door of the Elko County Courthouse. *Photo by Bill Oberding*

justice, and Kuhl would walk out of the Nevada State Prison a free man in 1945.

Errol J.L. Taber and Edward (E.P.) Carville would later play integral parts in Floyd Loveless's case.

Sixty years into statehood, Nevada opted for a more humane method of carrying out its death sentences. Toxicologist Dr. Allen McLean Hamilton proposed using lethal gas much like that used in combat during World War I. Nevada deputy attorney general Frank Kern liked the idea so much he persuaded Assemblymen J.H. Hart of Lovelock and Harry L. Bartlett of Elko to introduce a bill to use lethal gas exclusively.

On March 8, 1921, Hart and Bartlett introduced Assembly Bill 230. The so-called Humane Death Bill quickly passed the lower house and won approval of the Senate. Governor Emmet D. Boyle signed it into law on March 26, 1921: "The judgment of death shall be inflicted by the administration of lethal gas."

An airtight gas chamber was built in the prison yard for the execution of convicted killers Gee Jon and Hughie Sing, even as they appealed to the Nevada Supreme Court that gas was cruel and unusual punishment.

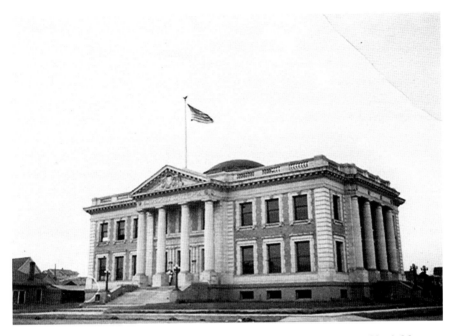

Elko County Courthouse shortly after its completion. *Photo courtesy of Northeastern Nevada Museum.*

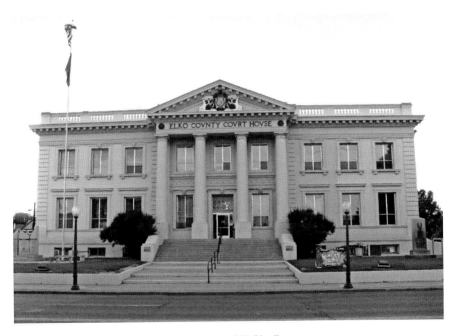

Elko County Courthouse, present day. *Photo by Bill Oberding.*

Hundreds of Nevadans agreed and signed a petition to halt the executions. Not being the shooter, Sing was spared. Jon was not so lucky. The Nevada Supreme Court denied his appeal, finding that gas was neither cruel nor unusual.

The court stated:

> *For many years animals have been put to death painlessly by the administration of poison gas....No doubt gas may be administered so to produce intense suffering. It is also true that one may be executed by hanging, shooting or electrocution in such a bungling fashion as to produce the same result. But this is no argument against execution by either method. It may be said to be scientific fact that a painless death may be caused by the administration of lethal gas.*

Because lethal gas was untried, a test run was necessary. After testing the new gas chamber on a pair of hapless kittens, the state was ready for its first execution by lethal gas. On February 8, 1924, Warden Denver S. Dickerson looked on as Gee Jon walked into the gas chamber, sat down and started crying. It was little comfort that long after his death, Gee Jon would be remembered as the first person so executed in the United States. According to Warden Dickerson, the job was done by four pounds of hydrocyanic acid gas into a chamber eleven feet long, ten feet wide and eight feet high, in which the condemned had been strapped to a chair.

In his report to the governor and the legislature, Dickerson said, "This method of execution, while no doubt painless, is not, in my judgment practical....The real suffering of the condemned, regardless of the manner of inflicting the death penalty, is endured before the actual infliction of the penalty."

Four years later, Bob White went to trial in Elko for the murder of local gambler Louis Lavell, whose charred corpse was discovered on property leased by White; their dispute was over money. White was convicted and sentenced to die. Traditionally, the condemned is asked about a last request. On June 2, 1930, just before the chamber door closed on Bob White, the warden asked him if he had a last request.

Pragmatically, White answered, "Why yes. I'd like a gas mask."

That same year, convicted serial killer Carl Panzram seemed to be in a hurry to get to wherever he was going. He stunned onlookers at Leavenworth federal prison when the executioner slipped the noose around his neck and asked if he had any last words.

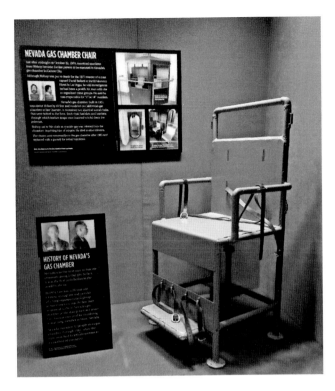

Actual chair that was used in executions at the Nevada State Prison gas chamber. *Photo courtesy Mob Museum National Museum of Organized Crime and Law Enforcement (Las Vegas) and Nevada State Museum (Carson City).*

Panzram did. "Hurry it up, you Hoosier bastard. I could kill ten men while you're fooling around!" he said.

When he walked into the Nevada gas chamber in June 1937, convicted murderer Luther Jones was asked if he had a last request. "I'd like to take the sheriff with me," he said. Jones, who had coldbloodedly murdered four Elko County men, was playing cards in Carlin when his pistol fell from his pocket. Notified of the firearm, Constable Berning attempted to arrest Jones, who balked. Bar patrons jumped in to help Berning subdue Jones. And off to the Elko County jail he went. En route, Jones asked Constable Berning what Nevada's method of execution was. Berning told him the state used lethal gas but couldn't get the strange question out of his mind.

While Jones languished in jail, authorities discovered he'd been busy bouncing checks in Elko. They were about to make a grislier discovery concerning Jones. After Berning told him about Jones's question concerning capital punishment, S.O. Guidici questioned Jones about three missing ranchers. It didn't take long for Jones to tell Guidici where to find the bodies; the deceased were three well-liked local men and an old man who happened on the crime. Elko was outraged. With talk of lynching growing louder, Judge

Original spectator chairs, in use since 1911, in the Elko County Courthouse. *Photo by Bill Oberding.*

Dysart realized the necessity of a speedy trial.

Local attorney C.B. Tapscott was assigned as Jones's defense counsel by Judge Dysart. Tapscott let it be known that he wanted no part of defending the man, even if it meant a contempt of court charge. In the end, Jones stood trial with Tapscott as his counsel. He was found guilty and sent to the Nevada gas chamber.

On September 28, 1942, the early morning sun shone across the Elko County Courthouse, lending an almost surreal glow to the building. Floyd didn't notice. After breakfast, he was hurried out of the jail, through the back door and up the stairs to the courtroom.

Judge James Dysart as a young man. *Photo courtesy of Northeastern Nevada Museum.*

Judge James Dysart. *Photo courtesy of Northeastern Nevada Museum.*

Those Elkoans who came to see Floyd Loveless's trial sat in straight-backed chairs that were original to the courthouse. Townspeople were anxious for this trial. Most recently, Luther Jones had stirred up community sentiment by murdering four of its own. But not since March 1925, when Mexican immigrant Guadalupe Acosta shot Deputy Sheriff Charles Lewis, did a trial involve the murder of a member of law enforcement. Racial tensions had run high. An angry lynch mob, demanding Acosta, gathered outside the jail. The lynching was prevented when seventy-five of Acosta's countrymen armed themselves and surrounded the building. And Acosta got his day in court. The jury found him guilty and sentenced him to death. But Acosta was fortunate. He was one of the few people whose death sentence was commuted to life imprisonment.

District Attorney C.B. Tapscott scanned his notes. A former Nevada state assemblyman, high school teacher and principal of Virginia City High School, Tapscott was ten years older and more experienced than his opposing counsel. This was his advantage. Both sides sat at the same long table. Tapscott looked at the defendant and his court-appointed attorney, Taylor Wines, who seemed unaware that Tapscott was watching them.

Spectators noisily jostled their way into district court judge James Dysart's courtroom. This was their community. They had read the newspaper accounts of Constable Berning's killing and of Loveless's confession to Sheriff C.A. Harper. Now they wanted to catch a glimpse of the murderous boy from Indiana.

News media were there to cover the trial of Floyd Loveless, who had the distinction of being the youngest person ever tried for a capital offense in Elko County. Constable Berning's family was not in the courtroom. Fifty years later, Berning's daughter Peggy Woods said they had not read the newspaper accounts of the killing or of the trial.

The jury (all male) was selected from a list of fifty-eight names from Elko and Lamoille, Ruby Valley. They were sworn in, and the trial was underway. The state's list of witnesses included Dale Cline, who would testify to his and Floyd's escape from Plainfield and their subsequent cross-country crime spree; the traveling salesman who chatted with A.H. Berning while he waited for the stolen Studebaker; the four deputies who had apprehended Floyd on Highway 40; and Drs. Wilsey and Roantree, who cared for A.H. Berning when he was brought into the Elko General Hospital. The prosecutor had proudly informed the newspaper that an FBI expert who would testify about the impossibility of Floyd's story was also scheduled.

Up first was Dr. David Brown Wilsey.

"The cause of death, can you tell us what that was?"

"The cause of death was a composite, namely, the shock factors; the infection factors from the course of the bullet; number three would be the paralysis factors or improper—"

Courtroom as it appeared at the time of Floyd Loveless trial. *Photo courtesy of Northeastern Nevada Museum.*

Tapscott stopped him. "In simple terms, what would you say the primary cause was?"

"[The bad damage] that had been created by the bullet namely is confined to the spinal cord region."

"And then was an autopsy performed?"

"Yes, sir, I did it."

Courtroom during an actual trial. *Photo courtesy of Northeastern Nevada Museum.*

Elko County Courthouse as it appears today. *Photo by Bill Oberding.*

"Did you ascertain the exact course of the bullet?"

"Yes, sir, I did, at the Arnold Mortuary, while Dr. Roantree stood by."

"What did you observe as to any bullet wound?"

"The primary investigation showed the man to have the powder buns from the bullet hole in the upper line zone of the neck, which had traversed backwardly, smashing into the front part of the body on the fifth cervical vertebra. As it went through, it caused a severing of the spinal cord almost as complete as if it had been done with a knife. The bullet then continued its path and was lodged in the tissue in the nape of the neck."

Floyd grimaced inwardly as Berning's injuries and death were explained.

"And the bullet was from where?" the district attorney asked.

Dr. Wilsey pointed to his diagram. "Approximately there."

"So the path was somewhat downward?"

"Slightly so," the doctor answered.

Floyd looked at the jurors, who listened intently to the witness.

Taylor Wines stood, straightened his tie and strode toward the witness stand. "Did Mr. Berning talk rationally?"

"Yes, sir, I would say he did."

"And you say the course of the bullet was downward?"

"Slightly so."

"There was nothing on which the bullet struck which caused it to go down?"

"Not on entering the body. It was probably given that downward course by contacting the rather firm bony vertebral body."

"Is it possible the barrel of the gun was pointed up or down?"

"Yes, sir, but as I understood your questions, you said upon entering the body."

Wines finished his cross-examination, and the clerk called Dr. Roantree to the stand.

After preliminary questions, the district attorney asked. "Doctor, in the past, as doctor, physician or surgeon, did you see Mr. Dolph Berning on August 20, 1942?"

"I did."

The questions and answers continued, but Floyd was barely listening. If only he could go back and live that day over again. If he could, he would be in Indiana; even Plainfield, with its harsh punishment, was better than this.

"Do you think that the death was caused by anything else other than the gunshot wound?"

"No, I do not."

"Was Mr. Berning able to talk?"

"Yes, he was."

"Do you recall seeing Warren Monroe at the hospital?"

"Yes, sir."

"What was Officer Berning's condition at that time?"

"I believe that was shortly after he was brought in. He could talk with some difficulty because of the blood in his throat, but mentally he was perfectly clear."

Floyd remembered the blood in the man's mouth and closed his eyes.

"Would you say that it was reasonably certain at the time Warren Monroe was there that Officer Berning knew that he was about to die?"

"I think he probably had a very good idea because he had acted as ambulance driver in a very great number of cases, and he realized he was paralyzed from the neck down."

"May I have this one packaged opened, please? I hand you what purports to be two leaden bullets, see if you can identify either or both of those objects."

The bullets—they were bringing out the bullets, Floyd thought. Realizing the jury was staring at him, Floyd kept his face a mask.

"Yes, those are the bullets," Dr. Roantree answered.

Judge Dysart said, "The two bullets will be admitted in evidence as State's Exhibit Number Two."

Taylor Wines was ready. "Are you certain that Mr. Berning knew his situation at the time he was brought to the hospital?"

"No."

Rodney Williams testified that he was chatting with Officer Berning about the stolen Studebaker when it pulled up. Berning told the driver he would have to take him in. When asked if the car's driver was in the courtroom, Williams pointed to Floyd. He then told the court that when he was about a half mile away, he looked in his rearview mirror and saw the passenger door of the Studebaker being closed from inside.

Dale Cline surprised onlookers as he approached the witness stand. Sixteen years old, he could easily have passed for a much younger boy. He glanced at Floyd and quickly looked away.

Tapscott was brusque. "State your full name."

"Dale Harold Cline."

"Before coming to Nevada, where were you living?"

"Indiana Reformatory."

"How long had you been there at the reformatory?"

"Two weeks."

"At the time of your leaving, who, if anyone, accompanied you?"

"Floyd Loveless." Dale glanced at Floyd who kept his eyes downward.

Tapscott continued questioning him until he came to the moment the two boys had left Elko.

"Who left town first?"

"Floyd did."

"Which direction did he go?"

"West."

"What did you do after he left town?

"I got in the Buick and followed."

"Did you get sight of him any place?"

"No, sir, not until we got almost to Carlin."

"Now, Carlin is—you refer to the first town west of here?"

"Yes, sir."

"About how long did it take you to get up there, Dale?"

"Oh, just about twenty minutes—fifteen or twenty minutes."

"About what speed were you driving after leaving Elko?"

"Seventy-five."

"When you arrived at Carlin, tell the jury just what you saw at the time you first saw Floyd there."

Dale turned toward the jury. "I caught up with Floyd before we got to Carlin, and I was driving right back of him and going along. And a red coupe, I believe it was, pulled up, and this constable got out of it and flagged

Floyd down. And I stopped right behind him, and the red coupe drove away, and this constable waved me around him and told me to go on."

"You are speaking of a red coupe. Are you sure that the constable you speak of got out of the red coupe or just talked with the man in the red coupe?"

"I am not sure. He was standing there when we drove up."

"The red coupe you speak of drove away?"

"Yes."

"That's while you were standing there?"

Dale didn't answer.

"Did you identify the man, see the man, who was in the red coupe and drove away?"

"No, I don't think I did."

Interestingly, Dale Cline was a state's witness whose testimony corroborated Floyd concerning his struggle with Constable Berning. Yet the state contended there had been no such struggle. Floyd, the state maintained, shot Constable Berning while he stood outside the passenger door. Tapscott took his witness to the time Berning waved him on.

"How far beyond were you when you looked back?"

"I am not sure."

"Tell the jury what you saw when you looked back."

"I saw Floyd and the constable wrestling around in the car, fighting or something. That is all I seen. I turned around and drove on." He looked at Floyd, who glared back at him.

On cross-examination Taylor Wines asked about Plainfield Reformatory.

"Did you have any reason for wanting to escape?"

"I didn't like it there."

"Was there any particular reason, any punishment or anything, that made you want to escape?"

"Well, I was afraid of getting a licking, but that isn't the main reason I escaped."

"What was the licking?"

"An ordinary licking."

"What did they lick you with there?"

"Leather strap."

"Would you describe it for us?"

"Five inches wide, a quarter of an inch thick and about three foot long."

"And was that all there was to it?"

"About all. It had a wooden handle, and I think it had wood on the other side, too."

"Who used this strap on these boys?"

"The supervisors."

"What did you do it for, what kind of infractions?"

"Just for punishment."

"Did they do it for everything, or was it only resorted to—"

"Just certain things."

"Just certain things. Did they do it very often?"

"Quite often."

"Did you ever see any boys who had been licked that way?"

"No, sir. I was right outside the building when it was going on though."

"Did they scream?"

"Some of them," Dale answered.

Wines moved on. Cline was obviously uncomfortable.

"Did you have any plans of any particular place you were going when you left the reformatory in Indiana?"

Dale looked at the Floyd and said. "California."

"Where were you going in California?"

"No certain place."

"No certain place. Isn't it true that you were supposed to go to California and stay in a cabin with you friends?"

"I haven't got a cabin at my friends. I was going to Santa Monica to get a job."

Wines took him to the morning of the shooting. "Floyd left town ahead of you?"

"Yes, sir."

"How fast did you say he was traveling?"

"Sixty-five or seventy."

"How fast were you traveling?"

"I was traveling about eighty. I was going faster than he was."

"How fast were you traveling when you came into Elko?"

"I don't know. We wasn't going very fast then."

"I didn't hear you." Wines stepped closer to the witness stand.

"We wasn't going very fast then," Cline repeated. "We slowed when we got to the city limits."

"I mean before you got to the city limits. How fast were you traveling before you got there?"

"Close to ninety."

After having Dale draw a diagram of the position of the three cars, Wines showed it to Tapscott and the jury.

"You drove up behind Floyd?" he asked.

"That's right."

"And he was parked this side of the road?" Wines asked, pointing to the diagram.

"Right-hand side."

"Was there any other cars there?"

"Yes, sir; the red coupe."

"Do you remember how close the red coupe and Floyd's car were?"

"No, sir, not exactly."

"Could you give us an estimate?"

Cline thought a moment. "Fifteen foot."

"And where was Mr. Berning?"

"Well, when he drove up, he was standing about three foot from the red coupe, and he waved Floyd down. Floyd stopped, and he walked over to Floyd's car. Coupe drove away."

"Then what happened?"

"He said something to Floyd's car and told me to go on, waved me around."

"How did he wave you around?"

Dale waved his hand. "Like this."

"Did he turn around from Floyd's car when he waved for—"

"I believe he did, left-hand window sill of the car, and left hand, like that, and he told me to go on. He was between me and Floyd."

"How far were you before you looked back?"

"I am not sure of that, 150 foot, I imagine. "

Wines glanced at the jury and then asked, "When you looked back, did you see the red coupe that was parked there when you first came?"

"No, sir, I didn't notice it."

"You didn't see it at all?"

"No, sir."

"But you saw Floyd's car?"

"I seen the coupe. I don't remember seeing it."

"Was the car sitting in the same position that it was when you left?"

"Floyd's car was."

"Were the doors closed?"

"I believe they were."

"And could you see someone struggling?"

"Yes, sir."

"Did you hear anything unusual?"

"No, sir."

"Did you ever look back again?"

"No, sir, I only looked back once."

"That one time you looked back, did you see things pretty clearly?"

"Yes, I seen pretty clearly."

"Did you look in your rear vision mirror, or did you look back and out the—"

"Out the back window."

"Out the back window. How far did you go before stopping?"

"To the filling station."

"Do you have any idea how many miles that would be?"

"No, I don't know exactly."

"What happened there?"

"I stopped and got gas."

"Did you have any conversation with the attendant there?"

"Well, when Floyd went past, I says, 'There's someone I was racing with.' Originally, I ordered two dollars' worth of gas, and I seen him went past, and I only had a dollar and a quarter in, and so I paid that and left."

"And the next time you saw him, he hailed you?"

"Yes, sir."

"And you drove about a mile, and he got out?"

"Yes, sir."

Floyd glared at Dale.

"How fast were you traveling, do you think, when you looked back the first time, look[ed] back that once?"

"Thirty or thirty-five. I had it in second gear."

"You had it in second gear?"

"Yes."

"You had the car under full control?"

"Yes, sir."

"And turned around and looked out the back window?

"Yes, sir."

Tapscott was ready with redirect.

"Dale," he asked. "You stated that revolver that Floyd had was taken in Indiana?"

"Yes, sir."

"And there was also a rifle taken before you left Indiana?"

"I think the rifle was taken at the same place the revolver was."

"What use did you make of those guns driving out, if any?"

71

"None. No use."

Tapscott looked askance at him. "Were they ever used to help you get through the country in any way?"

"Just we held up a filling station."

"In Omaha?"

"Yes, sir."

"Who held that up?"

"If the court please," Wines said. "I think that is entirely irrelevant in this matter. We shouldn't go into that."

"That question was opened up on cross examination, if the court please," Tapscott said.

"I see no need of that, Mr. Tapscott. The objection is sustained," Judge Dysart said.

"If the court please, I ask that the last question and answer be stricken," Wines said.

"Well," Judge Dysart said "the objection is sustained and the record will show that Mr. Wines."

"That's all," Tapscott said.

"Just a moment," Judge Dysart said. Then, turning to the witness, he asked, "Dale, during that conversation that you had beyond Primeaux filling station, I ask you whether or not Floyd Loveless said anything to you about where he had left the officer that was shot?"

Wines stood. "If the court please, I interpose an objection on the ground that the question is leading and asks for a conclusion. The witness had already testified all he remember concerning the conversation, and I further object that it is hearsay."

"Objection overruled."

Dale looked at the judge. "Yes, sir, he said he left him in the car."

"Anything further you want to ask?" Judge Dysart asked Tapscott.

"No further questions."

"You may be excused. You may step down," Judge Dysart told Cline.

Dale stepped from the witness stand. His eyes cast downward, he walked past Floyd, who stared absently at the courtroom windows. He must never let these people know how frightened he truly was.

Deputy Sheriff S.O. Guidici took the stand next. District Attorney Tapscott approached him, smiling affably. "You may state your name please."

"S.O. Guidici."

After taking his witness through the first report of the stolen Studebaker and the subsequent report of Constable Berning's shooting, Tapscott

asked, "Now, who, if anyone, did you contact or see at the Primeaux service station?"

"On arriving at the Primeaux service station, I noticed the gray coupe that was stolen, with the 1942 Nevada license number 26-519 parked alongside Primeaux station, or at least the building to the east of Primeaux service station. And on slowing down Mrs. Primeaux flagged us down, and she hollered at us there was a fellow walking down the highway, Highway 40, and we proceeded west and made an investigation as to who the party seen walking down the highway might have been."

"What did you do after leaving Primeaux station?"

"We proceeded west on Highway 40, and at a point between six and seven miles up, I believe, we noticed a fellow walking west on Highway 40, and on approaching him at a distance of about twenty feet, he flagged us down, raised his right hand and thumbed us down, in other words. We immediately stopped, and I informed Alexander—he was riding on the left side of the hind seat of the car, and I was driving—to get out and we'd see who this fellow was."

Tapscott looked at the jurors. "Incidentally, Mr. Guidici, prior to that time had you had any description of the person who had been driving the Studebaker car?"

"No," Guidici answered. "Some young fellow was all."

"What description, if any, did you have as to how he was dressed?"

"Some fellow with light shirt and rather dark pair of pants."

"Just where did you overtake this person on the highway?"

"Oh, it's the last slope going to Dunphy."

"About how far would that be from Dunphy?"

"From Dunphy," Guidici thought a moment, "I suppose about five miles east of Dunphy."

"How were you traveling?"

"Traveling by automobile."

"Is the person you saw at that time and overtook, present here in court?"

"Yes, sir," Guidici answered.

"Will you point him out please?"

Guidici pointed toward Floyd. "This here alongside of Mr. Wines."

"Do you refer to the defendant Floyd Loveless?"

"Floyd Loveless, yes, sir."

"Tell what transpired, what happened, what you did upon overtaking this individual?"

"Well, immediately after we stopped, I told Alexander to get out of the car— he was the handiest—and we were going pretty slow. Immediately, I followed,

both together. Alexander walked up in front of him and told him to put up his hands, and which he started to raise both hands and he later lowered his right hand and put it in his right trouser pocket, and being commanded to raise both arms, he complied, and Alexander searched his pockets for a gun. He didn't have any in his pockets, and later we found a gun in his shirt, inside his shirt."

"What kind of a gun? Will you describe it to the jury?"

Guidici turned to face the jurors and said, "It's a U.S. .38 revolver."

"At that time you took it from the defendant was it loaded?"

"It was, yes, sir."

"How many shells would it hold?"

"Five."

The revolver was identified through serial numbers and introduced as State's Exhibit Number One.

"Now at the time that you overtook the defendant and searched him, did you place him under arrest at that time?"

"Not right immediately, no."

"When, if ever, did you place him under arrest?"

"After questioning him. I ask him, I says 'Did you have trouble with an officer?'"

Wines stood. "Just a minute! I object to his giving any conversation at this time. No foundation has been laid. There is no evidence this defendant was under arrest."

"He says he was not under arrest," Judge Dysart said. "He just stepped out and spoke to this man. You may say who was present."

"Who was present Mr. Guidici? I believe we've already covered that."

"Deputy Sheriff Frank Goicoechea, Deputy Sheriff Alexander also special officer for the SP [Southern Pacific] and Dino Aiazzi."

Dysart asked, "Were you all out of the car at that time?"

"We were all out of the car at that time, yes, sir."

"Very well," Judge Dysart said.

"What was the conversation you had?" Tapscott asked.

"After we found the gun, we asked him, 'Did you have trouble with an officer?' and he says, 'No, sir.' And I says, 'Young fellow, you better tell the truth." And he says, 'Yes, sir, I shot——"

"Just a moment, please," Wines interjected. "I think the conversation now has gotten beyond the stage of preliminary questions by an officer, and no foundation has been laid for the conversation."

"Well, the objection is overruled," Judge Dysart said. And then, turning to the witness, he added, "And you may proceed with what was said."

"May I cross-examine the witness first?" Wines asked.

The judge answered. "You may when the time comes, Mr. Wines. But let's let Mr. Tapscott finish with this man."

After lunch recess, Wines began his cross-examination of Guidici.

"At the time you drove up to this young fellow on the road, what did you do?"

"Alexander was in back of him, and I went up in front of him. And in the meantime, Alexander was searching and found his gun in his shirt and handed it over to me."

"Did anyone have a gun in his hand?"

"I thought Alexander did when he walked up to him which he did when he walked up to him, but when he searched, he put his gun back in his pocket."

"Isn't this the gist of the conversation as you related it at the preliminary examination?" Wines asked.

"I object to that," Tapscott said. "The foundation has not been laid for the use of that transcript. It hasn't been established that it the official transcript."

"He can asked him if he so testified, and if he wants to see the transcript, he may look at it," Judge Dysart said.

"Do you want to see this transcript?" Wines asked.

"No, not necessarily," Guidici answered.

"'I said, "Did you have some trouble with the officer?" And he said, "No." And I says, "You shot the officer. You had better tell us right away you had trouble with him."' Did you make that statement?" Wines asked.

Guidici looked at the attorney. "I told him he had better tell the truth. I asked him if he had trouble with the officer, and he said, 'No.'"

"Did you make that statement on preliminary examination?"

"I don't remember the wording of it, if that is the wording."

Wines asked, "And at the time you made that statement, 'You better tell the truth.' Did you have a gun out?"

"I know Alexander didn't, and I know I didn't. I never did have my gun out. And Frank Goicoechea was in back of me, and I couldn't tell whether he had a gun out or not."

"Did you say someone told him to put up his hands?"

"Yes."

"And did they back that command by anything?"

"Alexander did when Alexander walked up, yes."

Wines turned from the witness. "I ask the court that the testimony of Mr. Guidici concerning the conversation with this defendant be stricken on the

grounds that it amounts to a confession and the proper foundation has not been laid. It shows that the conversation was extorted at the point of a gun and after admonishing him, 'You better tell the truth.' And all the authorities will sustain—"

"The motion is denied," Judge Dysart said.

"You say that he raised one hand and put one hand in his pocket?"

"Yes, he dropped one hand down to his right pocket."

"Did you afterwards look in that pocket?"

"Yes, he was searched. Alexander searched him."

"And did he find anything in that pocket?"

"No, not in that pocket."

"Did he make any threatening gestures?"

"No."

The promised FBI ballistics expert was not called to identify the gun; the inside of the barrel was so rusted that each shot made different marks.

Sheriff C.A. Harper was called to the stand. After a few questions to Harper, Tapscott proceeded to lay the groundwork for evidence that was sure to seal the defendant's doom—namely, Floyd's Loveless's confession.

"Now, Mr. Harper," Tapscott began, "going back to the defendant Floyd Loveless, when did you next see him after the evening of August 20, if ever?"

"On the morning of August 21," Harper answered.

"At what place?"

"He was taken out of the jail and taken up in the sheriff's office."

"At about what time?"

"At about 11:30 a.m., August 21, 1942."

"Who all was present at the time he was brought into your office?"

Sheriff Harper looked down at a piece of paper before answering. "Yourself, Mr. Tapscott and S.O. Guidici, W.F. Boebert, Harriet Williams, Floyd Loveless and myself,"

Tapscott looked at Floyd and then handed the witness a paper. "Will you identify this, Mr. Harper?"

"That is a confession made by Floyd Loveless at that time."

"Will you state the conversation that preceded the making of the confession as to all questions asked and answers given?"

"I informed Floyd Loveless that I was C.A. Harper, that I was sheriff of Elko County, and I was about to ask him some questions. Before those questions were asked of him, I would inform him that he was accused of shooting an officer with a gun and that the officer—and that if the officer died, he would probably face a charge for that offense. That he was informed

that he need not make a statement; that anything he might say might be used against him; that he was offered no inducement. No offer of reward, no threats were made against him, nor was he not compelled in any way. He was entitled to an attorney at his own expense. He was informed that those were his rights and asked if he wished then to make a statement."

"And what was his answer to that?

"He stated that he did."

"State whether or not the statement is signed," Tapscott said.

Harper nodded. "It is."

"By whom?"

"Floyd Loveless."

"When and where was that signed?"

"The statement was signed on the twenty-second day of August 1942 in the presence of Delpha M. Jewell, notary public, and also carries her seal of notarization. Before the document was signed, the questions were asked Floyd by Miss Jewell if he was compelled—being compelled, in any way, to sign the confession. He said, 'No.' She asked him if he was signing the confession freely and voluntarily. He said he was. She asked him if the contents of the confession were true, and he said it was."

Taylor Wines was on his feet. "I move that testimony be stricken on the ground it is hearsay."

"Objection overruled," Judge Dysart said. "It was in the presence of the defendant."

Tapscott then read Floyd's confession to the court and entered it into the testimony. When he tried to get Constable Berning's statement read into the record, Wines objected again. The objection was sustained. Berning hadn't realized that his death was imminent when he made the statement, so it could not be used as a dying declaration.

The next day would have been Constable A.H. Berning's fifty-seventh birthday.

"I pulled my gun, intending to hit him on the head, when he grabbed it and tried to take it away. I pulled the trigger and shot him, but he kept right on trying to get the gun, and in the struggle, the gun was fired again, and he fell over. I then started out to take him to the doctor."

Floyd broke down sobbing as Tapscott read his statement.

The jury was unmoved. It reached its verdict in less than fifteen minutes.

Floyd and Wines rose to face the jury. None of the twelve men looked at Floyd as the verdict was read: guilty as charged. The words echoed in his head. Guilty! He kept his face expressionless.

"Can we do anything?" he whispered to Wines.

"We can appeal after sentencing."

Before Wines could say more, deputies whisked Floyd from the courtroom. Taylor Wines shuffled papers into his briefcase. He hadn't expected any different. But there was still hope.

According to the *Elko Free Press* of September 30, 1942: "The fate of the 16 year old Indiana boy was sealed yesterday when he admitted upon the stand that he had shot Constable Berning twice and when his record, which astounded spectators and jurors alike, was read into the record by District Attorney Tapscott."

The record included the June 30 rape of Mrs. Knoth, which Loveless had neither been charged with nor convicted of. Floyd's attorneys seemed to believe that Floyd had confessed to the rape only to cover for his older brother Robert Kay.

While his attorneys may have doubted that Floyd Loveless raped Mrs. Knoth, his mail list seems to point to the veracity of his Indiana confession. While he was in prison, a written record was kept of all his incoming and outgoing mail. In standard procedure, two names on his outgoing list for October 19, 1942, are Mrs. Soller and Mrs. Knoth. Floyd wrote and mailed a letter to Mrs. Soller, the elderly woman whose home he burgled, and to the rape victim Mrs. Knoth. What he wrote to these two women was never revealed. The original date of his execution was December 13, 1942. It is likely that when faced with imminent death, he wanted to apologize and clear his conscience. Neither woman responded.

On October 6, Judge Dysart dashed Floyd Burton Loveless's hope by pronouncing the death sentence for him. The fifteen-year-old was slated to die during the Christmas season, December 1942. Toward that end, he was driven to the Nevada State Prison in Carson City, where he became inmate number 4506.

The old prison was overcrowded. Located at the southeastern edge of Carson City, the facility began accepting inmates in 1862. By the 1940s, the prison was too small to adequately house its inmate population of over three hundred. With the retirement of Warden Lewis came opportunity. And Governor Carville quickly appointed state engineer Richard H. Sheehy as warden of the prison in November 1940. Sheehy would be the prison's twenty-fifth warden. His first priority was to secure enough funding to enlarge the prison and alleviate cramped living conditions. As an engineer, he would be an invaluable asset in overseeing the building and enlarging of the prison.

Sheehy had served as warden less than two years when Floyd Loveless arrived. He had read the newspaper accounts of Floyd's crime and ultimate

death sentence. Still, he was taken aback at Loveless's youth. In his time there, he had never seen such a young inmate. Boys Loveless's age were in high school or off fighting the war, not isolated on death row with older, more callous men awaiting their own trips to the gas chamber.

Warden Sheehy accepted custody of his new prisoner and watched as the captain of the guard escorted the new inmate to processing. As part of that procedure, he was photographed and fingerprinted. In the official NSP photos taken of him that day (front view and profile), he wears standard attire, a casual blue cotton prison shirt. The oversized suit jacket was an attempt at decorum as much as it was to show how the inmate might appear in regular clothing. Looking at the official prison photograph of Floyd Loveless, two things are obvious: acne and the tears he blinks back. He was not yet sixteen; the bad-boy look of defiance is gone. In this photo, we see what Warden Sheehy saw—the face of inmate number 4506 is that of a scared kid.

Loveless would not be placed within the general population. His days were numbered. And death row inmates were separated from others. There was no escaping this place, which was far worse than Plainfield.

Floyd was still adjusting to prison life when Warden Sheehy received a plaintive letter from his grandmother Mrs. Leonard Burton (Nettie) Loveless:

October 29, 1942
Prison Warden;
Dear Sir.

I am writing to you in regard to Floyd Loveless. He wrote to me and said his case would come up before the prison board and that he could have a lawyer if he could pay for one.

We want to know if you know and would recommend a good lawyer for him and find out about how much money he would have to have. Do you think it would help any to get him a lawyer? None of us are rich but we want to go together and help all we can. If there is the slightest chance of Floyd's sentence being changed we want to do what we can.

If you could find out about a lawyer right away and let me know or maybe the lawyer would write me. Please do answer this as soon as possible as it means a lot to us and to Floyd too.

Yours Truly
Mrs. Len Loveless, Grandmother of Floyd.

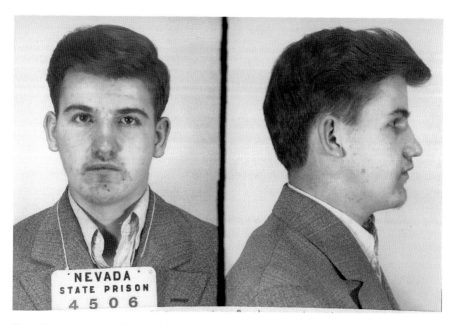

Floyd Burton Loveless Nevada State Prison inmate photo. *Photo courtesy of Nevada State Library, Archives and Public Records.*

On November 2, Floyd turned sixteen. Taylor Wines resigned from his obligation as acting district attorney; during a special election, Elko County residents had elected a new district attorney. That same day, Warden Sheehy responded to Mrs. Loveless's letter:

> *November 2, 1942*
> *Dear Mrs. Loveless,*
>
> *In answer to your letter of October 29, 1942, regarding the hiring of a lawyer for your grandson, Floyd Loveless, please be advised that I have today contacted Taylor Wines who was appointed by the District Court in Elko County to defend your grandson. I talked to him on the telephone and he seems willing to go ahead and handle the case. He stated that he would write to you today concerning this matter, so you, no doubt will receive a letter from him about the same time that my letter reaches you.*
>
> *Due to the fact that Taylor Wines was the only Attorney who knows anything at all concerning the case I believe he would be the proper one to handle same. This, however, is simply advice on my part and should you*

wish to make other arrangements you are at liberty to do so. Trusting that this is the information you desire, I remain

Sincerely yours,
Richard H. Sheehy WARDEN

Sometime during Floyd's first year in prison, his father and uncle came from Indiana for a visit. Kay was incarcerated in the Indiana State Reformatory (a Dillinger alma mater) at Pendleton and could not accompany them as much as he wanted to. Years later, he remembered his father showing him several photographs that were taken during this visit with Floyd.

According to Kay, the purpose of the trip was twofold. Ray Loveless wanted to see his youngest son (of his first marriage) and to bring him a "proper burial suit." If Nevada was going to execute Floyd, Ray wanted to make certain he would not be wearing prison garb when they closed the coffin.

Wines would appeal Floyd's death sentence. But this was wartime in a small community. After the Loveless conviction, Clarence Tapscott resigned as Elko's district attorney and enlisted as a second lieutenant in the marines. He was sent to Mare Island, California, for training, and Taylor Wines was appointed to take his place. As acting district attorney, he was not permitted to work on Floyd's appeal. With an execution date two months away, every day counted.

On October 29, 1942, in an attempt to save Floyd's life, his grandmother wrote to Governor Carville.

In her letter, Mrs. Loveless told Carville about the death of Floyd's mother and about his stepmother and how she disliked him. In grandmotherly fashion, she assured the governor that Floyd was a good

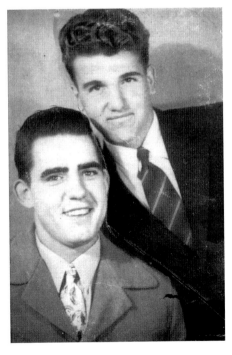

Floyd Loveless (*right*) and an unidentified friend. *Photo courtesy of Robert Kay Loveless.*

81

Ray Loveless on a train. *Photo courtesy of Mike Loveless.*

boy who went to church. She continued: "Ever since Floyd was eight he has bought his own clothes and school books. Last winter he got into trouble and was sent to live with his aunt. Then he got into more trouble. He has had a hard sad life."

On November 17, 1942, Reno attorney Oliver Custer arrived at the office early for a scheduled meeting with Ralph G. Wales, director of the Western Branch of the National Probation Association. Wales had expressed an interest in assisting in the Floyd Loveless case if possible. And Custer, who also wanted to help the boy, was anxious to hear what Wales had to say. He looked at the calendar and at his watch and settled in his chair. It was a good thing Wales was coming before the snow started up on Donner Pass. If the weatherman was right, he would beat the snowstorm but would have no time to waste in getting back down the hill before it struck.

His secretary, Mrs. Parks, knocked softly on the door before stepping in. "Telegram," she said handing it to him.

Custer quickly read, "Sorry unable visit with you today special work called me back here am writing Mr. Wines in Elko others interested Loveless case. Hope you keep in touch with me interested help in any way possible Ralph G. Wales National Probation Assn 110 Sutter Street."

He folded the sheet. "Start a Floyd Loveless file and put this in it," he instructed Mrs. Parks.

That same day, Nevada governor E.P. Carville issued the following proclamation, setting Thursday, November 26, as Thanksgiving Day for Nevadans:

Whereas a nation at war pauses in the midst of turbulent activities to offer reverent thanks to our Almighty Father for the blessings he has bestowed on us.

Whereas the very spirit of Thanksgiving emanated from a small band of patriots who were resisting oppression much the same as we are today liberty shall live.

Whereas now, more than ever before in history, do we need divine guidance to lead the way through the dangers of peril.

Now therefore, I, E.P. Carville, governor of the state of Nevada do hereby proclaim Thursday, November 26, as Thanksgiving Day and call upon all the citizens of Nevada to join in paying solemn tribute to God for the bountiful manifestation of his protection in our fight against a godless enemy.

I further urge her citizens to pray for our boys on the battle lines—expressing our heartfelt feelings for their safe and speedy return and to display publicly the stars and stripes for which they are fighting.

When the war is won it will be by the champions of Right and Truth and Justice—the forces represented by those valiant men and women of the United Nations who are proud to be a part of this glorious march toward freedom.

November 18 came gloomy and gray to Reno; storm clouds hovered in the Sierras, and wind swept across the Truckee Meadows. Oliver Custer flipped the desk reading light on and read the morning newspaper. His mind was still on Floyd Loveless and the death sentence that hung over him. Something had to be done; no boy so young had any business in the gas chamber. Custer called his secretary into the room and dictated a letter to his friend Richard Sheehy, warden of the Nevada State Prison.

Dear Dick:

Will you please advise me when the death sentence is to be executed upon Floyd Loveless? I understand from the newspapers that he is to be executed sometime in December.

Do you know whether or not any stay of execution has been granted by reason of an appeal to the Supreme Court of Nevada?

Thanking you for an early reply, I am with kind regards, Sincerely Yours.

Oliver Custer

Still wanting more information, Oliver Custer wrote to Mary Catherine Blakely of the Nevada State Welfare Department Division of Child Welfare Services.

Dear Miss Blakely

I am very much interested in the case of young Floyd Lovelace [sic] who was recently convicted of murder and sentenced to death sometime in December of this year.

I have talked with Mrs. Sally Springmeyer and also with Mr. Wales of the National Probation Office in Washington; also with Judge Hawkins of Winnemucca, and they have interested me in behalf of young Lovelace.

I am most anxious to learn whether or not Mr. Taylor Wines, the attorney at Elko, who was appointed by the Court to defend Lovelace has made a motion for a new trial in this case.

Will you please examine the records in the Clerk's office at Elko and find out whether or not a motion for a new trial was made, and if so, whether Mr. Wines is taking steps to appeal the case to the Supreme Court of Nevada. I should also like to know if he has taken any other steps toward staying the execution of the death sentence set for December. I will appreciate your very prompt attention to this matter as I am most anxious to get this information.

I thought it would be best to write to you because I knew you could get the information for me and I was afraid the Clerk of the Court might delay in sending me the information.

I have the pleasure of seeing your mother and father quite frequently at our church. I hope that you are well, and that you are getting along nicely with your work.

With kind personal regards, I am Sincerely Yours.

Mary Catherine Blakely responded:

Dear Mr. Custer;

As soon as I was able to when I arrived in Elko this morning I learned that Mr. Wines had filed a motion for a new trial in the Floyd Loveless case. This is the only step taken so far toward staying the execution of the death sentence.

The records for the motion for a new trial were sent out Wednesday so the attorneys will likely appear in Carson in about two weeks.

I hope this is the information you needed, and thank you so much for your interest in the boy. Sincerely Yours.

Custer quickly read through her response and then dictated a letter to Judge L.O. Hawkins.

Re: Floyd Loveless
Dear Judge Hawkins;

Thank you for your letter of November 27.

I was advised by Miss Blakely, Child Welfare Service, at Elko, that Mr. Wines has filed a motion for a new trial in this case. I therefore feel certain that he will take an appeal to the Supreme Court. In the event, however, the Supreme Court should affirm the decision of the District Court and Mr. Wines fails to raise the point regarding the juvenile act, then this case, in my opinion, could be taken again to the Supreme Court by a petition for habeas corpus. I shall watch the appeal with great interest, and if I may be of any assistance, I will be only too glad to help.

I wish for you great success in your new location at Las Vegas, and I hope that you will find the practice both remunerative and interesting. My congratulations and best wishes to both you and Mr. Lewis.

With kindest regards, I am sincerely yours.

Hawkins had first approached Custer about the case. It wasn't that Judge Hawkins was averse to the death penalty. He had handed down the death sentence to twenty-eight-year-old Luis Ceja for a 1930 murder. But he felt that executing someone as young as Loveless would be an illegal act by the State of Nevada.

On Tuesday December 1, a response to a letter Custer had written to Alan Bible, deputy attorney general, was in the morning mail.

Dear Oliver,

For your information the Record on Appeal in the case of State vs.
Loveless *was filed in the Supreme Court last week and an Order Staying
Execution was entered on Saturday, November 28, 1942, pending hearing
and determination of the appeal.*

My personal regards, yours very truly

Alan Bible Deputy Attorney General

The news of Floyd's conviction and death sentence didn't surprise
everyone in his small hometown. Some felt the local bad boy had gotten
just what he deserved. Others felt it was the lack of parental guidance that
was to blame. Weeks before the scheduled execution date, a Shelbyville
schoolteacher sat down and typed a letter to Governor Carville.

November 24, 1942
Dear Sir:

*May I introduce myself as a Hoosier school teacher and a former friend
and teacher of Floyd Burton Loveless?*

*As the day nears for his execution I feel that my conscience would forever
bother me if I did not make some plea in his behalf. I doubt seriously if you
have received many such pleas.*

*I have known "Bert" for about 10 years having taught in Stockwell,
Indiana for seven of those ten years. That he has come to the point where he
is I am not surprised, but whether he is responsible to the extent of paying
with his life—I doubt.*

*He had two strikes on him from the time he was born. His father received
a dishonorable discharge from the army after being in a brawl in which a
man was killed and he has always been feared by the residents of Stockwell
as a desperate character without any principle. He was found robbing his
own father's (Bert's grandfather) store and has been caught in numerous
thefts of meat, etc. on farms in the community.*

*Bert's mother was accidentally killed or she committed suicide while he
was still a baby. She stepped in front of a train. Community opinion was
that it was probably suicide brought on by the life she was forced to live.*

*On one occasion Bert's father, step-mother and two brothers went to Ft.
Wayne, Indiana on a trip leaving Stockwell on Thursday. Bert refused to go*

as he would have had to miss school. (At that time he had a man, Mr. Drake, who he respected very much, for a teacher.) Friday morning I learned of the situation and questioned Bert, finding out he had had no supper or breakfast and had broken into his home, spending the night in the house without a fire. I sent him home and Mrs. Thompson gave him a good breakfast. I also took him home for lunch and he was very appreciated [sic]. I had to go back to school early and Bert did a number of chores for my wife. Thinking to repay our kindness he drew a cowboy and presented it to Mrs. Thompson.

I do not want to be classed as a silly sentimentalist, but after all I feel that Bert is just 16, has known little but training in crime since his cradle days and that he is not altogether responsible for his acts.

He is dangerous and I would not plead that he ever be turned loose on society again. However, with the intelligence that I know he possesses I feel that he could be made into a useful member of your state prison population.

While I am completely without legal education it is my understanding that the state demands that we pay for our crimes and it [is] with that view point in mind that I ask that you consider a change of sentence in Bert's case from death to life imprisonment. In this way he would pay for his enormous crimes without paying the supreme price that should be assessed against one mature enough to realize what he was doing.

Respectfully yours,
Lawrence W. Thompson

Governor Carville replied by a form letter thus:

Dear Mr. Thompson:

I wish to advise you that your letter of November 24 in behalf of Floyd Burton Loveless has been received.

It is my understanding that the attorney that was appointed to defend him will make application for commutation of sentence and in that event there will be a hearing set sometime during the early part of December. The Board of Paroles and Pardons, of which I am chairman, will at that time review the case. At that hearing your letter will be brought to the attention of the other members of the board and will be given serious consideration.

Very truly yours,
E.P. Carville Governor

While Oliver Custer attempted to find a way to help in Floyd's defense, a group of Reno women also worked toward that end. Headed by Mrs. Pearl White, the group wrote letters and actively sought donations to help with the boy's legal fees. Contributions came from many individuals, as well as the Palace Club, the Club Fortune, 222 Club, Virginia Bar, the Bartenders Union Local 86, the Elmhurst Guest House and the Reno Musicians Union Local 368.

Floyd Loveless as a youngster. *Photo courtesy of Robert Kay Loveless.*

Not everyone in Reno was eager to help Floyd stay out of the gas chamber. Constable A.H. Berning was born and raised in Carson City. His parents had been young German immigrants when they met and married in nearby Genoa. As a young man Berning worked at the Virginia City Virginia and Truckee Railroad roundhouse.

Many still associated the historic Abe Curry home with the Berning family; the house had been the family residence for several years. A number of Berning friends and extended family members resided in the Reno/ Sparks Carson City area. None of them wanted to see Berning's killer escape punishment.

By December 1, 1942, Floyd had been at the prison three months. Being locked away from the outdoors and the sunshine was hard for him. The loneliness was unbearable. There was no one here his own age. Nobody understood. If he had kept his promise to his grandmother and stayed at Plainfield, he could have been a barber.

He didn't want to die any more than the man he had left in the Studebaker, the man bleeding and begging for a doctor. But that man had died. Soon others would be celebrating Christmas, and he would walk into the gas chamber in payment of that death. He was resigned. Dying was better than rotting in this place forever.

Floyd was eating lunch when the warden came to his cell, smiling broadly. "You've been granted a stay of execution, Floyd."

Floyd nodded.

The warden waved to a man who stood in the corridor. "This gentleman is from the newspaper. He'd like to speak with you."

Floyd stared at the man. A pencil rested across the top of his ear, like an arrow. He opened his notepad and smile hopefully at Floyd.

"I'm Mr.—"

"I've got nothing to say."

The two men retreated down the corridor, speaking in hushed tones. *Motherless lad, too young to be here*—the same words he had heard in Indiana. They meant nothing. He was here.

Floyd picked up his sandwich and gobbled it hungrily.

In Elko, Taylor Wines prepared his appeal. From his office at the Henderson Bank Building, Wines could see the railroad tracks and the busy streets below. This was his community; he was born and raised here. He understood Elko better than an outsider ever could. He realized feelings here ran deep against Floyd Loveless, but Floyd was a child. And no child should be waiting to die in the gas chamber. There was much work to do.

1943

On April 21, 1943, the news was good. The Nevada Supreme Court ordered a new trial for Floyd because the Elko jury had not stated what charge they found him guilty of. When asked the verdict, the jury foreman said, "Guilty as charged" instead of "Guilty of first-degree murder." The new trial date was set for November 15, 1943.

Floyd wrote to his dad and his grandmother before leaving for Elko. None of his family back home in Indiana expected he was going to walk out of prison a free man. But they prayed for a less severe punishment. Floyd was eager to get out and see some of the countryside, even if he was doing so as a prison inmate. Maybe this time, they would not give him death.

By November 14, 1943, he was back in Elko. On the drive in from Carson City, they came across a desert snowstorm that blanketed the mountains and iced the roads. As the car pulled into town, Floyd stared out the window. Elko was as alien to him as it had been on that day in August. It had been only fifteen months since he and Dale had first driven

Area of Elko where Taylor Wines's office was located. *U.S. Library of Congress.*

into this town. Now it was all a blur. The car slowed at the courthouse and turned toward the jail. This was familiar. He would never forget this place as long as he lived.

It was a bitterly cold day, not warm like the first time he had been here, and his breath came out in puffs of fog as they led him from the car to the back door.

The next morning, Floyd was led into the same courtroom. He looked around quickly. There were not as many people as the last time, and the prosecutor was different.

"All rise."

Floyd stood. His heart sank as Judge Dysart entered the room.

With jury selection over, Judge Dysart turned to his clerk, "Mrs. Caine, you will please read the information to the jury and the defendant's plea."

The clerk read, "Gentlemen of the jury, to the charge in information the defendant pleads not guilty."

The first witness called was Rodney S. Williams. After asking a few questions about Williams's employment, District Attorney Wright asked, "Did you happen to be in the vicinity of Carlin, Nevada, on August 20, 1942?"

"Yes," Williams answered.

"Did you notice anything unusual in and about Carlin that morning?"

"As I left, or in town?"

"As you left."

"Yes."

"What was it that you saw?"

"I was stopped by the constable of Carlin given instructions to be on the lookout for a car, Studebaker, gray car, five passenger, and at that time he gave me the license number."

"Where did that take place?"

"At the Y, where the old road that goes into Carlin meets the new road."

"And then did anything further occur?"

"Yes. After he had given me this number, I looked up and saw a gray car approaching, and as it approached, I recognized it and then read the license number to him."

"Did you see who was in the gray Studebaker coupe?"

"Yes."

"Will you kindly describe him or identify him, if you can?"

"He was a boy between eighteen and sixteen, not too tall, dark complexioned, young man."

"Can you point him out?" Wright asked.

Williams nodded and pointed toward Floyd. "Yes that is him there."

Floyd looked absently at the man who sat on the witness stand.

"Where did the coupe stop?"

"Opposite my car, not exactly opposite, before it stopped."

"When it stopped where was Officer Berning in reference to the car?"

"Between the two cars."

"Then what did you see take place?"

"He flagged this car down, and he said, 'I have got to take you in, Buddy.'"

"Was there any reply?"

"The boy said, 'Why?' "

"Then what further did you notice?"

"Mr. Berning motioned for me to move on, because there was another car [that] had stopped, and it was apparent [that] his movement was to let the other car go by."

"Where did it stop?"

"Right directly behind the Studebaker."

When it was Wines's turn to cross-examine the witness, Floyd glanced at the man and then stared down at the desk. His testimony concluded,

Williams stepped down from the witness stand. "You may be excused from further attendance," Judge Dysart told him.

Jailer Edward Kendrick took the stand and related events surrounding the report of the stolen Studebaker. After questioning Kendrick about his report to Berning, the district attorney asked, "Did you have any later communications concerning that gray Studebaker coupe automobile?"

"I did."

"About what time of the day?"

"It was about an hour after I put in the call to Mr. Berning."

"What information did you receive concerning the coupe at that time?"

Kendrick looked in Floyd's direction. "I received a call in the office from Primeaux station, saying that the car was located there west of Primeaux station and Mr. Dolph Berning was shot and laying alongside of the car."

Wright finished with Kendrick, and Wines began his cross-examination. Finally, he asked, "You were jailer at the time the defendant was confined during August and September?"

"I was."

"Where was he confined in relation to Dale Cline?"

"One was downstairs in the felony tank, and one was upstairs in the misdemeanor tank ward."

"That is all." Wines said, turning from the witness.

Dino Aiazzi was the next state's witness to take the stand.

"How long have you resided in Carlin, Nevada?"

"All my life, about thirty-seven years."

"What is your occupation?"

"Mechanic."

"On August 20, 1942, were you in Carlin, Nevada?"

"I was."

"At that time did you have anything to do with Officer Berning?"

Aiazzi didn't understand the question. "You mean—?"

"Did you have anything to do on August 20, 1942, in connection with Officer Berning?"

"I did."

"Kindly tell us what you did that day?"

"Deputy Sheriff Guidici came in and deputized me."

The story of how Floyd was apprehended was told again. This time, however, there were only two men to testify to it. Of the four-man posse that had arrested Floyd, two had died since the first trial: Deputy Sheriff Guidici and Deputy Sheriff Goicoechea.

In February 1943, twenty-two-year-old Frank Goicoechea suddenly became seriously ill. The young deputy sheriff lingered for two months before dying of a "malignant heart ailment" on April 2, 1943.

S.O. Guidici died one month later. The longtime Elko County deputy sheriff had easily beaten his opponent and been elected constable of Carlin in the November 1942 general elections. But the fifty-one-year-old suffered from a serious illness from the time he took office and remained hospitalized until his death on May 4, 1943.

While cross-examining Aiazzi, Taylor Wines asked, "At the time that you first saw the defendant on the road, did you carry a gun?"

"I did not."

"Did Mr. Alexander?"

"Yes. All I had was a rifle."

"You had a rifle?"

"Yes."

A few more questions intervened and then, "So you had your rifle with you?"

"No."

"You left that in the car?"

"Yes."

"How close did you get to the defendant?"

"Close enough that I got ahold of his hands."

"You got ahold of his hands?"

"Yes."

"How close was Mr. Alexander?"

"Standing right back of me."

"Did you say that Floyd Loveless reached for something?"

"He was going for his pocket."

"He reached for his pocket?"

"Yes."

"Where was the gun taken from him?"

"Right above the belt in his shirt."

"However, his hand reached for his pocket?"

"Yes."

"At the time Mr. Guidici was talking to the boy, he was under arrest?"

"He was."

"Did anyone at that time inform him he was under no obligation to make a statement?"

"All I know is what Guidici told him. He asked him if he had any trouble with the officer."

"Yes, but did he say at that time that there was nothing to compel him to make a statement?"

"He never said a thing."

While he listened to Aiazzi answering Taylor Wines's questions, Floyd looked out the window past the judge. If he thought about it, he could remember every detail about that afternoon; other times, he didn't want to try. Most nights, he went to sleep wishing he would wake up and be back in Plainfield, wishing he had never headed west, wishing he had never come to this place.

Aiazzi was finished. "You may step down, Mr. Aiazzi," the judge was saying. Floyd watched Alexander sit down in his place.

"Your name is H.B. Alexander?" District Attorney Wright asked.

"Yes, sir."

"Where do you live Mr. Alexander?"

"Carlin."

"How long have you lived in Carlin?"

"Ten years."

"On August 20 1942, what was your occupation?"

"I am employed by the Southern Pacific Company as investigator and police officer."

"At that time did you have any police officer standing as a county official?"

"I was deputized as a special deputy sheriff."

"On August 20, 1942, did you have anything to do with a certain affair involving Officer Berning?"

"Yes, sir."

Wines was on his feet. "Objected to as the question is leading; he might ask if anything unusual happened that day."

Judge Dysart nodded. "That may stand."

Wright asked, "What first did you do in that connection, or who contacted you?"

Alexander thought a moment. "Well, the first thing that happened, as I remember, someone asked me if I had heard about Berning being shot, which I had not at that time, and I questioned them as to where it happened and they said right around—"

"You are not to relate any conversation," Wright admonished him. "Did you some time that day see Officer Guidici, on August 20, 1942, deputy sheriff?"

"Yes, sir."

"Where?"

"At Aiazzi's Garage."

"Who were present?"

"There was Deputy Sheriff Frank Goicoechea, Dino Aiazzi and Guidici."

"And yourself?"

"And myself, yes." Alexander smiled.

"What, if anything, did the four of you do?"

"Well, we drove out Highway 40."

"How far did you go before you stopped?"

"We went as far as Lovelock—that is, during the day."

"I mean," Wright explained. "Where did you first stop?"

"At Primeaux service station."

"Then you proceeded westward?"

"Yes sir."

"Where was the next stop?"

"I believe, as well as I remember, it was at a gravel pit between Primeaux service station and Dunphy Ranch, where the highway construction company was getting gravel."

Wright looked at the jury and then back at his witness. "Where was the next stop?"

"The next stop was where we found a young fellow on the highway hitchhiking."

"Can you identify that person?"

"Yes, sir."

"And who?"

Anderson looked at Floyd. "Young lad sitting over there by Mr. Wines," he said

"You indicated Floyd Loveless?"

"Yes, sir."

"Where was he when you first saw him?"

"He was walking along the highway and he seen our car and stopped and thumbed for a ride."

"What, if anything, was done at that time concerning this hitchhiker?"

"Well we had information that the man we was looking for would probably be hitchhiking on the highway, and when we came in sight of this lad, Guidici said—"

"Objected to as being hearsay," Taylor Wines interjected.

"What Mr. Guidici said, just tell what was done with regard this defendant," Judge Dysart instructed the witness.

"Well we pulled [up] and stopped, and I got out and covered this lad with my gun and told him to hold up his hands, which he did. I walked around and searched him and I found a gun on him."

"Where did you find the gun?"

"Right down in front of his pants."

"What side of the Guidici car did you get out of?"

"On the left-hand side and went around in front."

"Now when the search took place you found a gun?"

"Yes, sir."

"What did you do, and what did the other officers do, and what did the defendant do or say from that time on?"

Anderson thought a moment. "When I took the gun off of him I handed it to Officer Guidici, and put my gun back in its holster, and I finished searching him to see if he had anything else on him."

"You say you had put your gun back in your holster?"

"Yes, sir."

"What, if anything, was said by the defendant, Floyd Loveless, at that time?"

Wines jumped up. "Objected to as not having sufficient foundation for any testimony."

Judge Dysart turned toward the district attorney and said, "I think you had better lay a better foundation."

"What time of day was it?"

"Approximately 12:15 p.m."

"Who was present?"

"Dino Aiazzi, Frank Goicoechea, Guidici and myself."

"And where were the other three, Bill Guidici, and Frank Goicoechea and Dino Aiazzi, at that time after you handed to the gun to Bill Guidici?"

"Well, "Anderson said, "I hardly know how to explain. They were all in front of Loveless, and I was behind him.'

"Did anybody at that time have their gun drawn?"

"No, sir, I don't think so."

"Was there any conversation at that time, while all of you were on the highway there, concerning the defendant, Floyd Loveless?"

Taylor Wines was on his feet again. "Just a minute. That is objected to as leading, and I renew my objection on the ground that sufficient foundation has not been laid."

"At the time, after you took the gun from the defendant, had the defendant been placed under arrest yet?"

"Yes, sir."

"Had anybody so informed him?"

"Yes, sir."

"Who?"

"Bill Guidici."

"Did anybody have any conversation with the defendant Floyd Loveless at that time?"

"My objection is renewed, if the court please," Wines said.

"He is not asking what the conversation was. If he had any conversation, he can answer that," Judge Dysart said.

"The objection is withdrawn," Wines said.

"Yes, sir." Anderson answered.

"Between whom was the conversation held?"

"Bill Guidici and Floyd Loveless."

"What if anything was said at that time?"

Wines spoke loudly, "Objected to, if your honor please, on the ground sufficient foundation has not been laid."

"I think that is right," Judge Dysart said. "This witness has testified that the defendant was under arrest and nobody informed him as to his rights. Did you hear Mr. Guidici tell this boy that he was under arrest yourself?"

"Yes, sir."

Wright asked, "Was that before or after the conversation?"

"Before."

"Have you read over your testimony at the previous trial?"

"Yes, sir."

(The official transcript does not contain an objection to the question; however, Wright's next statement seems to indicate that one may have been made.)

"I just want to know if he had refreshed his memory." Wright said.

Dysart said, "You can find that out. If you have been taken by surprise, you can show it."

"Do you recall the type of gun that was taken from the defendant?"

"Yes, sir."

"What type please?"

"It was a thirty-eight caliber, U.S. printed on it, and also the serial number."

"Do you have the serial number?"

"Yes, sir."

"Do you have it in your possession now?"

"Yes, sir."

"Will you kindly tell us—first, let me ask you, when did you get that serial number?"

Alexander nodded toward Floyd. "Immediately after taking it off this boy."

"Where?"

"On the highway."

"Are you positive it is the same gun you took from the defendant? The serial number you took down, did it come from the same gun you took?

"Yes, sir, that is where I got it."

"I show you State's Exhibit Number One and ask if you can identify that?"

"Yes, sir, that is the gun."

Floyd could feel the jury's eyes bearing down on him. Avoiding their eyes, he stared sullenly into space, wishing himself anywhere but here.

"Are you positive in your identification that the defendant here, Floyd Loveless, is the same person you saw there on the highway?"

"Yes, absolutely." Anderson said, staring at Floyd.

Wright stepped away from the witness stand. "That is all at the present time."

Taylor Wines spoke to Floyd and then approached the witness stand. After a few questions about the time of day the arrest took place, he asked, "Do you know what sort of weapon, if any, Mr. Aiazzi had with him?"

"No, I don't."

"Do you know if he had any?"

"No."

"Do you know if Mr. Goicoechea had a weapon, a firearm?"

"I wouldn't say."

"Did Mr. Guidici?"

"Yes."

"However, you were the first person to reach Floyd Loveless?"

"Yes, sir."

"You were behind him?"

"When I got out of the car I was facing him, but I immediately went behind him."

"At that time, you searched him and put him under arrest?"

"Yes, sir.

"How far from the western end of the construction work was it before you saw the boy?"

"I am not sure, but I would judge four to five miles."

"Do you remember when you got there?"

"Approximately 12:15."

"That is to the place where the boy was?"

"Yes."

"That is all," Wines said.

Aside from the two deceased deputies, several witnesses had left the area. Elko deputy sheriff Bill Critchley was called to testify to the attempts that had been made to locate all the witnesses.

Wight asked, "You are a deputy sheriff of the county of Elko, state of Nevada?"

"I am."

"How long have you resided in this county and state?"

"Since 1896, with the exception of about ten years."

"Sometime in the month of November 1943 did I place in your hands a subpoena for certain witnesses?"

"Yes," Critchley said, "you did."

"Did the subpoena call for the subpoenaing of the—will you kindly name the witnesses please?"

"David, Brown Wilsey, Ed Kendrick, Rodney S. Williams, Dale Cline, Louis Stilson, Glade Peterson, S.L. Mendenhall, A.B. Madsen, Arthur O'Brien, R.P. Roantree and C.A. Harper."

"Has a subpoena been served on Louis Stilson?"

"No, we were unable to find Louis Stilson in the county."

"What, if anything, did you do to find Louis Stilson?"

"We sent a letter to his former employer, W.W. Clyde, to get his last address."

"Did you have a reply from W.W. Clyde, his employer?"

"Yes, we had a reply from Mr. Clyde here on November 6."

"What information did you have as to the present whereabouts of Louis Stilson?"

"If the court please, I object to that on the ground any information which the witness can testify to now is merely hearsay by means of a letter, and he has no means of identifying it. It would be secondhand evidence." Wines said.

"He can show what efforts he made to locate him." Judge Dysart said.

"Yes," Wines said, "he has testified he sent a letter to W.W. Clyde in order to get a reply from him, but he can't state the contents."

Judge Dysart saw it differently. "He can state what information he obtained. The objection is overruled." He turned to Critchley. "You can state what information you obtained as to where this witness was."

"His last known address was Springfield, Utah."

"Well, I haven't a copy of it here," Wright said.

"Do you recall whether you did or did not mail such a letter?" Judge Dysart asked the witness.

"No, I don't recall, Your Honor."

"Well," Wright said, "I will ask you, pending the location of that letter, these others. Did you do anything to ascertain the present address of Glade Peterson?"

"Yes, we notified and served him by registered mail, and we have a reply back from his stepfather that he don't know where he is at."

"Did you get information concerning his present whereabouts?"

"Yes, we have a letter."

"What is the information as to his present whereabouts?"

"He is at Camp Tyson, Tennessee, serving his country in the armed forces."

And so it went; a number of witnesses who had testified at Loveless's first trial would not be in court. Their testimony from the previous trial would be read.

Critchley was excused, and Dr. David Brown Wilsey took the stand.

"Dr. Wilsey, on August 20, 1942, did you have occasion to see Officer Dolph Berning?"

"Yes, sir, I did."

"Where?"

"At the Elko General Hospital."

"About what time?"

"Approximately eleven fifteen to eleven twenty in the morning."

"What was his condition at that time?"

"As I have said previously from this same witness stand, he was a man particularly and acutely ill following a gunshot wound in the front part of the neck, which had in the course of the bullet passed through the vertebrae of the neck region severing a great part of the spinal cord, thereby causing, as related to breathing, paralysis and the like, along with some factor of—"

"I ask that the answer be stricken. The witness has not been qualified as an expert," Wines said.

"Dr. Wilsey, are you a practicing physician and surgeon?" Wright asked.

"I am."

"Where?"

"Elko, Nevada, with the Elko Clinical Group, doctors Hood, Roantree and Secor."

"When were you admitted to practice in the State of Nevada?"

"In 1941, May of that year I believe."

"If the court please, I wish to offer in evidence the testimony of Dale Cline, which was given at the trial held on September 28, 1942, held in this court in this matter."

"That is objected to, if your honor please," Wines said. "The proper foundation has not been laid. So far it has not even been shown that the transcript is the original in the matter, and it has not been shown sufficiently that Mr. Cline is out of state."

"It might be well to ask. I haven't started to read it yet, but I can identify this transcript," Wright answered.

"As far as Mr. Cline is concerned, I think you showed positively that he is out of the jurisdiction of this court, so as to that the objection is overruled. You will have to identify that as the original transcript," Judge Dysart said.

"May I call Mrs. Caine in this connection, please?" Wright asked.

Dysart answered, "I think the statutes provide that if the court reporters certificate is on it that it can be used by either party and read in evidence."

Mrs. Mae E. Caine, county clerk of Elko County, was called to testify that she had certified the correct judgment roll, notice of appeal, transcript and bill of exceptions. Mrs. Caine also testified to the legitimacy of the signature of court reporter Elizabeth Smiley on the documents.

"And," asked Wright, "this is the original transcription and record of the former case, is that correct?"

"Yes," Mrs. Caine answered.

As she stepped from the witness stand, District Attorney Wright said, "Just a minute, if the court please. I am informed that a United States Marshal is on the phone and he would not be able to get Cline here until Friday. If it is necessary for him to be brought here that is the first date, and he is on my phone now."

"That is entirely too late," Judge Dysart said. "We can't keep this jury waiting."

"Tell him that the trial is in progress, and we can't hold the trial over," Wright said to his assistant. "If the court please, may I read the testimony of Dale Cline, which commences on page thirty-eight, line twenty-four, in the transcript of the former trial commencing September 28, 1942?"

"May we have a stipulation if your honor please, that the objections taken during the progress of the testimony shall be automatically taken as he reads this time in order to prevent my interrupting him when I would ordinarily make such objections?" Wines asked.

"You mean your objection to any part of it?" Wright asked.

Judge Dysart said, "He asked that any objections he has made—"

"That will be stipulated," Wright said.

"And," Wines said, "if there are any further objections I shall state the grounds."

"Very well," Judge Dysart said.

Storm clouds had blown in from the northwest, lending an ominous appearance to the courtroom. Wright cleared his throat and began reading Dale Cline's testimony. Listening to Dale's words, Floyd thought of the day, which seemed so distant now. Jurors looked at the district attorney and then at Floyd. Wright finished reading and placed the papers on his table.

"If the court please, at this time I desire to offer in evidence the testimony of S.O. Guidici, commencing at page fifty-six of the transcript of testimony at the trial of September 28, 1942, on the grounds that he is now deceased."

Judge Dysart looked at the jury. "Would any of you gentlemen like to have a few minutes recess, or would you like to go on?"

"We might take a five minute recess," Wright agreed.

On November 27, 1943, Taylor Wines filed a written motion for a new trial and motion in arrest of judgment in Elko.

That same day, in Carson City, thirty-four-year-old Floyd McKinney was executed for murdering an Idaho couple in central Nevada. Because of his stoicism in the face of imminent death, newspapers dubbed McKinney "the gamest man ever to be gassed in the Nevada lethal cell."

Floyd Loveless's motion for a new trial was denied on November 30, and he was once more sentenced to death.

OLIVER CUSTER HUNG HIS overcoat on a peg. Settling into his chair, he unfolded the morning newspaper.

His secretary knocked softly on the inner door. "Will you see Mrs. White and Miss Semenza?" she asked.

He thought a moment and asked, "Is this about the Loveless boy?"

"It is."

"Show them in," he said, pushing the newspaper aside.

"Mrs. White. Miss Semenza." He stood and motioned the two women to chairs that faced his desk. "Please have a seat, ladies. Would either of you care for a cup of coffee?"

"No, thank you," Miss Semenza said.

"Not for me, thank you," Mrs. White said.

He turned from the desk and filled his cup from the office percolator. Steam rose from the cup. "With sugar rationing, I've gotten used to drinking mine black."

The women nodded knowingly. After a cursory discussion of the weather, Mrs. White began. "We won't take a lot of your time Mr. Custer. As I told you last week, we represent a group of ladies who are

most interested in saving the life of this boy." She waved a gloved hand at the other woman. "Miss Semenza, as you may know, is the Child Welfare Director."

Custer smiled and nodded. "Yes we've met."

"As I understand it, Mr. Custer, you are somewhat familiar with this case?" Miss Semenza asked.

"Somewhat," Custer agreed. What he knew, he had read in newspaper accounts of the second trial.

"It's terrible what is happening with this boy," Mrs. White said. "He needs our help. So we've come to ask you to represent him in an appeal to the Supreme Court."

"I don't know ladies—"

"Many prominent people are interested in this child's case, Mr. Custer," Mrs. White said.

He sipped his coffee. "I'm sure. However, I couldn't get involved until—"

Mrs. White interrupted, "I believe I can raise enough money to pay your attorney fees if that's what's bothering you."

'It's not that," Custer said. "Mr. Taylor Wines is the boy's attorney. I would have no right to enter the case unless he was withdrawn." He turned to the other woman. "Miss Semenza, I suggest you write to Mr. Wines and ask him about the status of the case."

She smiled. "I will write to him this afternoon."

The women stood, and Custer shook their hands warmly. "I look forward to hearing what Mr. Wines has to say."

After they left he took out his notepad and scribbled a reminder to himself. The plight of the youngster sitting on death row had grabbed his interest. Whether or not he could help the boy was another matter.

Taylor Wines turned to the second page of the newspaper and read an editorial in the December 14, 1943 Thursday edition of the *Elko Daily Free Press*:

A group of Reno women are reported to be interested in saving Floyd Loveless, killer of Constable A.H. Berning, from death in the Nevada gas house. He is 17 years of age. They are interested in saving him because of his youth. This might be a commendable attitude if Floyd Loveless was some other 17 year old youth and if his record was different that it is. This cold blooded killing of Constable Berning by Loveless would be considered cause enough by most people for his execution. If that wasn't

enough there is his past record, which became part of the record at his first trial here. His record shows a life of crime, one flagrant example being the holding of a woman at the point of a gun while he raped her. Loveless does not deserve to live. Nothing beneficial can be accomplished by saving him from death, with the possibility that he may be turned loose upon the general public again. But these same women might be able to accomplish some good for humanity if they would exert their influence against juvenile delinquency. We are all prone to wait for disaster before acting. The thing we should do is to put our energies into a program which will avert juvenile delinquency—such projects as the ice skating rink now being sponsored by the city of Elko. The best tonic for any child is to keep him active and thus keep him out of trouble.

Attorney Taylor H. Wines has announced that he intends to take the case to the Supreme Court for a review. He admits that there is little chance that the verdict of the jury trial will be reversed. However, Attorney Wines recognizes, as any reputable attorney must, that he has an obligation to his client, which must be fulfilled. It is only right that the law take its full course in the case of Floyd Loveless to see that justice is done.

The editorial didn't surprise him. He folded the newspaper and looked at the stack of mail on his desk. A long slender envelope with the return address of Oliver Custer caught his eye.

He opened it and read with interest.

Miss Semenza advises me this morning that she has received a letter from you in which you state that you are carrying an appeal to the Supreme Court of Nevada and that you would be glad to have me associated with you in the case....I shall be glad to assist you in this matter and I shall await your further advises. I am looking forward with pleasure to meeting you for I have heard a great many complimentary things about you. With the seasons greeting, I am sincerely yours

Oliver Custer

Wines had another client facing a murder charge—with a large caseload. Custer's offer to help with Floyd's appeal was welcome news. He replied that same day.

Dear Mr. Custer;

Miss Grace Semenza has written me that several persons in Reno have interested themselves in the Loveless case, and have asked me whether I would desire to have you associated with me in the appeal of the matter. I have replied that I would be very happy to make such an arrangement and thought perhaps I should write directly to you and briefly familiarize you with the facts and points which I believe should be set out in an appeal.

To begin with you should not be taken in by the newspaper story that Floyd is a confessed and convicted rapist since I have obtained information from the records in the East and compared them with the story which the boy gave the officers at the time he was arrested and they do not compare closely enough for a conviction. There is, for example, the fact that the lady was unable to recognize Floyd Loveless the next day and in a statement he very definitely said the lights were on, and at present I do not recall whether or not Floyd said he had a mask on or whether the lady said the person who assaulted her had a mask on, but any rate that is another particular in which the stories differ from the facts. Because where she testified that the person who assaulted her had a mask and Floyd said that he did not or vice versa. There are a number of other details which escape me at present showing that the boy is covering up for someone else. The past record of the boy shows that he has on occasion taken the blame for crimes committed by associates or his older brother.

Wines then went on to explain his points to the other attorney.

For several days after being brought back to Elko there was considerable complexity in the District Attorney's office as to how to proceed with the boy and it was finally concluded that a petition should be filed in the Juvenile Dept. of the District Court, at that time I was appointed to represent Floyd at that hearing.

The showing there made by the District Attorney is precisely the same showing which the District Attorney would make at the preliminary hearing; i.e., a showing of probability of the boy having committed the crime, etc. There was no effort made to show that the boy was unfit for reformation and the Court made no such finding in its order thereafter made. After studying the applicable Statute (1019) on that point I have come to the conclusion that a proper showing was not made at that time, however, the

order dismissing the petition in the Juvenile Dept. was made and the Justice of the Peace of Elko Township ordered, upon application of the District Attorney, to hold a preliminary hearing. The order made, dismissing the petition is faulty and ambiguous.

The order recites that certain persons were served, etc., that the Court finds that there is probable cause for believing that the boy committed the crime of first degree murder, that there is probable cause for believing that the boy is approximately 16 years of age, it should be noted here that there was not one word of evidence proving or disproving the age of Floyd at this hearing in the Juvenile Dept. That thereafter the petition of the District Attorney was dismissed and the order to the Justice of the Peace was made.

After listing the arguments he intended to use, Taylor Wines concluded his letter:

There will be a number of matters which you will like to have fuller information on and you will very likely desire copies or originals of a number of papers filed in the matter, and if it is your wish to be associated with me in this appeal and to have further information please let me know.

Yours very truly,
Taylor H. Wines.

Oliver Custer replied to Wines. And for the next nine months, they would fight to save Floyd Loveless. Decades after Loveless went to the gas chamber, Custer would say of his and Wines's work on the case, "We tried."

In a December 21, 1943 letter to Custer, Wines wrote:

I have pretty definite information that the jury at the last trial did not take a vote on the punishment to be inflicted in this case, and an error might be assigned for that reason on the ground that it is the duty to at least find whether or not they disagree on that point. I am trying, at present, to get one of the jurors to make an affidavit to the effect that a vote was not taken on that matter.

Governor Carville was also receiving letters concerning the plight of Floyd Loveless.

December 30, 1943
Dear Governor Carville,

There is a matter that I wish very much to bring to your attention. I know that you are a very busy man, but I believe you will find time to think this over and please help with; that is the boy, Floyd Loveless, that is to pay with his life for the fatal shooting of a man representing the law at Elko, Nev. I know of course, that this was a terrible thing, but terrible things happen every day and in as much as this boy is an under-privileged child he really is a victim of society. From a letter I received from him Christmas, there is a lot of good in him. I have written Father Flannigan [sic] and I am enclosing his answer. I wish you could please see fit to commute his sentence to a more lenient one, and since Father Flannigan would like so much to help out, perhaps the boy could be paroled to him. We all know Father Flannigan would make a man of him. Any way I just can't think that the State of Nev. wants to go down on record as having taken a child's life when only a few weeks back a woman at Ely deliberately shot and killed a man at a table through jealousy and only received a life sentence.

We are employed by the S.P.R.R. and ever so many men and women are in favor of the boy and donating to the cause. Different clubs such as Catholic Welfare Society and St. Agnes Guild and many others, the Unions Club and numerous organizations are interested.

Hoping that you will please see fit to take a hand in this matter as one in your position can help so much.

Respectfully Mrs. K.R. Whitney

Chapter 4

1944

From the Fields There Comes
the Breath of New Mown Hay

January 2, 1944
Dear Mrs. Whitney,

I have your letter of December 30ᵗʰ and appreciated your view-point and interest concerning Floyd Loveless, this interest being due primarily to his youth.

His case is now being appealed to the Supreme Court of the State of Nevada and further action will necessarily await the decision of that Court. If the Supreme Court affirms the decision of the District Court the next process will be a commutation hearing before the Board of Paroles and Pardons. If the case does come before this Board, of which I am chairman, I shall have your letter in mind and bring it to the attention of the other members of the Board. Naturally, at this time I am not in a position to make any commitment relative to the action that might be taken if a commutation hearing is had and we must wait for further developments.

With Kindest wishes for the New Year, I am Sincerely yours,

E.P. Carville, Governor

Desperate to keep their client out of the gas chamber, Wines wrote to Custer on January 11, 1944:

Concerning the possibility of appealing to the Board of Pardons and Appeals in the event our appeal to the Supreme Court is not successful, I believe I could do the boy more good as a witness before the Board of Pardons and Appeals than as his attorney especially since I have probably been the only person to whom the boy has ever shown any real trust. I have heard the jurors here remark again and again they might have considered the matter differently if he had shown any emotion or regret for his action in the Court room. I would not have to reveal anything of a confidential nature in order to give that body an idea of how the boy actually feels. In the Court room he maintains an attitude of indifference and defiance which does not sit well with either the judge or the jury, but in talking to me he is altogether different.

Kindest regards,

Sincerely Taylor H. Wines.

Custer responded on January 14, 1944:

It is my belief that if we are unsuccessful in the Supreme Court that we can have the sentence commuted to life imprisonment. As I heretofore have stated, many persons have expressed sympathy for this boy, both to me and to Mrs. White. Yesterday Mrs. White advised me that Father Collins who is one of the prominent Catholic priests in Reno and who devotes most of his time to social welfare advised her that he would do everything in his power to have the sentence commuted to life imprisonment. He told her that he would be glad to appear before the Board with you and seek commutation. Your suggestion that you appear before the Board as a witness is a good one. However, in the case of John A. Kramer, I appeared before the Board of Pardons and Paroles two times in an effort to have the sentence commuted. On one of the times I decided to have Kramer appear before the board as a witness. The Board, however, refused to permit this as being against the rules. They did, however, permit me to introduce an affidavit made by Kramer and they also permitted the Attorney General's Office to submit an affidavit made by Jim Collins, the attorney at Ely who had represented Kramer. Therefore in this case I think we could certainly introduce your affidavit and that I could present the whole matter to the Board. I know of certain other prominent people in the state whom I know are interested in this boy and it is possible that I could have them appear before the Board and ask for commutation. I expect to devote as much time as possible on this case, and shall advise you before long as to what progress I am making on the portion of the

brief which I will attempt to write. I shall appreciate your advising me regarding the above matters upon which I have asked for instructions from you.

With kindest regards, I am sincerely yours.

Nearly two years had passed since Floyd and Dale ran away from Plainfield, two years since he had been home. He missed them all. After writing to his father and grandmother, Floyd wrote to Oliver Custer on January 16, 1944:

Carson City Nevada
January 16, 1944
Dear Mr. Custer,

It's been requested that I write you a letter. I'll try my best but it will probably be short.

As you can see I haven't made any to [sic] *much of my life. I'm young yet and I hope it isn't to* [sic] *late to make good.*

I was 15 when I got into this trouble and I was 15 when I first came here. I am 17 now.

Rev. Harvey of Carson City has my birth certificate. You can get it from him. I've had one year of high school. I can get the certificate if it is needed.

I'm working here and I pray and hope for the best.

If I'm given another chance, I'll make good. I've got to make good. You see I've been away from home for quite awhile [sic] *and I'd like to get back and be like one of the rest.*

Sincerely yours,
Floyd B. Loveless

His letter to his attorney completed, Floyd wrote to the Whites:

Dear Mr. and Mrs. Ed White,

I received your letter this afternoon and I was glad to receive your letter. I'm sorry I haven't wrote before now. I like to write but it's not so easy to think of something to say.

I'm going to be good as I know how. I'm easy to get along with. I'm not looking for trouble. I've decided which road I really want to take. I've got [two] *very good reasons why I want to make good. I've got other good reasons* [too] *but those* [two] *come first. One is* [to] *show this world as*

well as my hometown that I can make good. Another is that there's a girl waiting for me. I guess those are good reasons.

Mr. Oliver Custer I have heard never gives up. He's the fighting kind.

My Dad's address is Mr. Ray C. Loveless R.R. 1 Lima Road, Fort Wayne, Indiana. My oldest brother lives with a cousin of mine but I don't know his address. My other brother address is Robert Kay Loveless, Reg No 30540 Pendleton, Indiana. He's in a tough place and I don't think he will be allowed to write.

Although he's got about two years more he's coming out here after his times up. You see we got into trouble at the same time. He was placed in a different place than I. It was the first time I was away from my relatives. I didn't like it. I think I was there a month. I had promised my grandma I would stay there but I had endured a little more than I wanted. I would have been a barber when I left. I now wish I had stayed there.

My grandma sent my birth certificate. It says I was born November 2, 1926.

I'm now on the yard with the rest. It's sure good to get some fresh air. I never was much of an indoors boy. Everyone was glad to see me out. They say I've gotten taller and fat. I must weigh about 175 now. I always was a pretty big boy. I hope to be as big as a six foot cousin of mine. I'm not six foot yet but I hope in the next 5 & 6 years I am.

Well I guess this is about all. I want to thank every one of you that are helping me. I'll do my best.

Sincerely yours
Floyd Loveless

Oliver Custer replied to Floyd with the following on February 2, 1944:

Dear Floyd,

I received your letter of January 16 and was glad to hear from you.

Mr. Taylor Wines and I are now working on the brief to be filed in the Supreme Court on the appeal. We are hopeful that we may be successful in that appeal. It will probably be several months yet before the Supreme Court passes upon the appeal. We shall keep you advised of developments.

With kind regards, I am sincerely yours.

Floyd wrote and received a lot of mail. His existing prison file shows that his outgoing mail included letters to his brother Robert Kay in prison in Pendleton,

Indiana. Years later, Kay would remember that they were not permitted to exchange letters. Any news of the incarcerated brothers was shared by family members who took the time to write. Aside from family, numerous well-wishers wrote, as well as *Detective Story* magazine and Hollywood Film Studios in Oakland, California. On the morning Floyd received Custer's letter, it was his only mail for the day. He read it eagerly and wrote back immediately on February 3, 1944:

Letter from Floyd Loveless to Oliver Custer. *Author's collection.*

Dear Mr. Custer,

I received your letter today. I am glad to hear from you. Glad you received my letter. I had a couple of photos made of my birth certificate and sent one to you and Mr. Wines. I have the original of the birth certificate.

How long is my stay of execution? I got a letter from my Dad yesterday and he said if there was any way for him to help me, he would. If you would like to write to him, his address is Mr. Ray C. Loveless. Lima Road. R.R. 1, Fort Wayne, Indiana.

I'll sure be glad to hear of any developments. It's kinda hard to wait and know of nothing.

Sincerely yours,
Floyd Loveless.

Oliver Custer and Taylor Wines were corresponding regularly. Any gossip concerning their client was eagerly shared between the two attorneys.

March 4, 1944

Mrs. White advised me yesterday that the Catholic Priest, Father Collins, had talked with Governor Carville at Las Vegas, Nevada, and that the Governor told Father Collins that the boy should receive a commutation of his sentence in the event the matter was presented to the board of pardons and paroles. I am convinced that we can secure a commutation if it becomes necessary for us to ask for one.

Mrs. White also advised me today that she expects to secure some additional small contributions within the next week or so. I shall immediately forward one half of any sums that she delivers to me.

With kind personal regards, I am Oliver C. Custer.

May 3, 1944

A cover-all statement such as was made by Judge Ducker should not be allowed to foreclose discussion of errors again. Since many errors, none in themselves sufficient to cause reversal, taken as a whole may make it plain that the defendant did not receive a fair trial.

Taylor Wines

June 2, 1944

On May 31 I saw my friend Dick Sheehy, warden of the state prison. I know Dick quite well and have found him a very reliable person. Dick mentioned during our conversation that he believed from the information which he had that in the event Loveless' conviction was not reversed by the Supreme Court, that the Board of Pardons and Paroles would commute his sentence.

Oliver Custer

THROUGH THE SYCAMORES THE CANDLE LIGHTS ARE GLEAMING

On June 16, 1944, fourteen-year-old George Junius Stinney Jr. was executed in the electric chair at South Carolina's state penitentiary in Columbia. The execution of the youngest person in twentieth-century United States

intensified Floyd's attorney's efforts. Floyd wasn't aware of the fourteen-year-old African American youngster who went to his death amid pleas for commutation by the NAACP, churches and unions.

The same day that George Stinney Jr. went to his doom in South Carolina, Nevada attorney general wrote to Elko district attorney George Wright:

Friend George,

I called upon Chief Justice Orr this morning with respect to a date for oral arguments in the Loveless case. Justice Orr, in communication with the other Justices, agreed to a date sometime in the week of July 10, providing such date would be acceptable to the respective parties....A copy of this letter is being sent to Mr. Wines and Mr. Custer for their information and we trust that a date in the week of July 10 will be acceptable to all.

Kind personal regards, very truly yours

Wines and Custer were fighting on his behalf. But he chose not to think about what would happen if they failed. Like most teenage boys, his interests were cars, baseball and the war—and girls. There was that special girl waiting for him back home in Indiana. Maybe one day, he would get back to her and home.

He didn't really want to look too far ahead. He was happy just to be out with the others. Since being permitted into the general prison population, Floyd was able to get outdoors, exercise and join in on softball games. He was a likeable kid who played well. Those who weren't under sentence of death felt sorry for him and put him on the prison softball team, the Nevada Prison All-Stars. Later, fellow teammates would say he had been their star player.

On Sunday, June 18, 1944, the All-Stars team played an exhibition game of softball against the 947th Guard Squadron. Floyd was at second base; the *Nevada State Journal* reported that he played spectacular ball. For a moment, he forgot that he was there under sentence of death. Being young, he may have seen death as something in the faraway distant future. The public came out to watch the game, which the NDP All-Stars won easily. There would be other games and other seasons, but not for Floyd Loveless. This would be his only season.

On June 30, softball was momentarily forgotten; the mood at the prison turned somber when thirty-one-year-old Raymond Plunkett was executed in the gas chamber for the murder of his five-month-old son.

Floyd would be next, unless his sentence was commuted. Numerous people took time to write letters to the governor. A group of Reno High

School students let their feelings be known by adding to the letters that poured in to the governor.

Among those letter writers asking for commutation was Father Flanagan, founder of Boys Town.

July 11, 1944

Honorable S.P. Carville
Governor of Nevada
State Capitol
Carson City, Nevada

My dear Governor Carville:

I am writing to you in behalf of Floyd Burton Loveless, a 17 year old boy confined in your State Prison under sentence of death. This boy was convicted of murder, and resultant sentence of capital punishment has been appealed to the State Supreme Court.

I do not question the justice or injustice of the retribution demanded by law as a result of this boy's actions. I seriously doubt, however, that the forfeiture of the young man's life will in any way relieve or ameliorate the wrong which has been done, whether deliberately or impulsively. Floyd Loveless was an adolescent boy when this offense occurred, and consequently it is somewhat questionable whether the rigidity of criminal law should apply to his situation. For any lesser offense, it is probably that the case would be handled by a lesser court as an instance of juvenile delinquency; hence, it is the degree of the offense rather than the culpability of the offender, which receives primary consideration.

It would be a tragic thing if society demands the life of this young man, in payment for the unquestionable offense which he has committed, rather than making a determined effort to rehabilitate the tangled and confused personality fabric which Floyd possessed because of his neglected earlier years. I only wish that I could offer a haven to this young man at Boys Town, but his is older than the group for whom our program has been devised. However, other agencies exist which could do much toward the molding of a worthwhile citizen, in contrast to the negative approach of mortal punishment. I truly hope that you will find it possible to intercede in this boy's behalf, and grant him whatever executive clemency might be possible under the circumstances.

Sincerely yours,
Rt. Rev. Msgr. E.J. Flanagan

One of the most compelling letters written for commutation came from district judge L.O. Hawkins eleven days before Loveless was executed. Hawkins, who had met with Loveless in the Humboldt County jail shortly after he was apprehended, wrote.

My dear Governor;

I am writing on behalf of Floyd Loveless who as I am informed petitioned the Board of Pardons and Paroles to have his sentence of death commuted to life imprisonment; which petition is to be acted upon on the 22ⁿᵈ of this month.

Have mailed to the Board of Pardons and Paroles two petitions signed by approximately ninety residents of Las Vegas, Nevada. One of those petitions bears the signature of nineteen lawyers actively engaged in the practice of law here at this time; five of the lawyers here are not signers of the petition, three of them not being available and two declining to sign the petition. I talked the matter over with Judge George Marshall before preparing the petition and was informed by him that he was wholly in sympathy with the purpose of the petition and believes as I do that there is a grave question of the legality of executing a child under the age of 18 years in Nevada, but felt it better that he not sign the petition, as it might be considered as implied interference by the Judge of one court with the acts of a Court of similar jurisdiction.

About five years ago I tried an Indian boy in Lovelock on his plea of guilty to the charge of murder and after hearing the evidence and exhaustively studying the authorities construing juvenile acts similar to that of Nevada, sentenced the boy to the state's prison for life. That boy was only a week or two short of being 18 years of age at the time he shot and killed one of the most prominent and well-beloved women of Lovelock, and was passed 18 years of age when the charge of murder was filed against him.

In studying the juvenile laws of this state and other states at that time and reading many authorities where juveniles were accused of murder, spending at least fifty hours in investigating and reading many decisions of cases, the result of that investigation satisfied me it is the intent and purpose of our juvenile laws, if not is legal effect, that a child under the age of 18 years is not to be executed for his crime; no matter what the circumstances, and because of that belief I sentenced that Indian boy to life imprisonment rather than to be executed. His crime was premeditated, and without any element of justification and provocation; a cold-blooded wanton killing.

No one can justifiably accuse me of being unwilling to impose the death penalty in a proper case, as I have imposed that sentence several times; once in the Ceja case (53 Nev. 272) on a plea of guilty and without trial by jury.

Now since the recent conviction in the Loveless case I have studied over our juvenile and criminal laws many times; have read many additional authorities and am satisfied that the execution of Loveless by the state of Nevada will be an illegal and unlawful act; something that should be prevented. While I am not criticizing anyone having to do with that prosecution, the verdict, the sentence or the affirmative of the death sentence flowing from the verdict of guilty of murder in the first degree; I do insist that those responsible therefore have not gone into the matter of the punishment to be imposed upon juveniles when the charge against them is a capital one as thoroughly as possible, and believe had they read all the authorities available regarding that matter they would have concluded as I have. There is enough doubt concerning the legality of imposing a death sentence in Nevada to justify the commutation of that sentence to life imprisonment. I sincerely hope you will vote to commute the sentence of Floyd Loveless from death to that of life imprisonment.

Yours truly,
L. O. Hawkins

HOLDING OUT

It was summertime again. Mrs. Nettie Loveless could hear children laughing as they went about their play. Only a few summers ago, the laughter of her grandson Floyd was part of the noise. He, his brothers and the dog would run back and forth, back and forth, until the little boys dropped of exhaustion, the dog panting heavily. She glanced at the shelf of photos. There was Floyd, in his white baby dress, tottering toward the camera—forever, just a sweet baby. She dabbed at her eyes with a handkerchief. She didn't believe that Nevada would go through with the execution—she had to hope they wouldn't. She picked up her fountain pen. She had to write another letter.

July 25, 1944
Dear Mr. E.P. Carville,

Once more I am writing about my grandson Floyd Loveless hoping you will spare his life he is so young and he was a good boy everyone liked him he was liked by all his friends until this awful thing happened to him. Please spare his life I no [sic] he has done wrong but I think God has forgiven him. I have been praying for him and I no [sic] you are a good man. And surely he could be spared from Death. Everyone feels so sorry for him. It seems just like a dream,

I wish it was. He was always so good to me. I hope you will do all you can for Floyd. I can't be with him to share his trouble. God will take care of him is my prayer. Hoping to hear from you.

Mrs. L.B. Loveless.

Governor Carville responded on August 2, 1944.

Dear Mrs. Loveless,

I have your letter of July 25th and I want you to know that you have my deepest sympathy at this time when you are suffering for your grandson.

At the present time I do not know whether Floyd's case will come to the Floyd Loveless as a baby. *Photo courtesy of Robert Kay Loveless.* *State Board of Paroles and Pardons, of which I am Chairman. If it does come before this Board at a commutation hearing, I want you to know that the verdict that is given by the members of this Board will be one that is made after most serious consideration of all phases of the case.*

I have inquired of the Warden how your grandson is and have been told that he is in good health and that he has been a good boy while he has been an inmate of the Nevada State Prison.

Very truly yours,
E.P. Carville Governor

The verdict came in August. The Nevada Supreme Court denied Floyd Loveless's second appeal. Wines had contended that the killing of Constable Berning was second degree (which would have carried a lesser sentence). The court disagreed. In the opinion written by Justice Ducker, it is stated,

We cannot lend our assent to this view. On the contrary, the circumstances of the case are such that we feel no difficulty in determining that the jury were well justified in finding that the killing of the officer, was willful, deliberate, and premeditated.

Putting aside the evidence which discloses that the accused was a criminal character who, shortly prior to the killing had traversed the streets of Elko armed with a concealed and deadly weapon, looking for an opportunity to commit a crime.

"The judgment and order denying the motion for a new trial appealed for are affirmed, and the district court is directed to make the proper order for the carrying into effect by the warden of the state prison," the judgment rendered. Judge Dysart set the execution date for September 29, 1944.

August 16, 1944
Dear Taylor
RE: State V. Loveless

I have just received a long distance telephone call from Mrs. Brodigan, Clerk of the Supreme Court. She advises that in a unanimous opinion written by Justice Ducker the Supreme Court affirmed the judgment of the Elko County District Court carrying a death sentence and directed the lower court to make the proper order for carrying into effect the judgment rendered. I presume that I will receive a copy of the opinion tomorrow.

Within the next few days, I will go to Carson City and see Loveless at the State Prison and have him sign a written application for commutation of his sentence from death to life imprisonment. In the meantime I have called Mrs. White and she will commence circulating a petition in Reno, petitioning the Board to commute the sentence to life imprisonment. She has also called Judge Hawkins at Las Vegas and requested him to circulate a similar petition. I assume that it would be futile to circulate a petition at Elko. However, if you think it wise, I suggest that you get some friend to circulate a petition there.

I am still hopeful that we can get the Board to commute the sentence. I will keep you advised of developments here.

With kin personal regards, I am sincerely yours.
Oliver Custer

On August 18, 1944, the day after the Supreme Court denied him a new trial, Floyd reached out for help. At the behest of fellow inmates, he chose to turn to Frank B. Robinson, the controversial founder of the Psychiana religion. Robinson, who founded his mail-order religion during the Depression, regularly advertised his books and lessons in different publications. Robinson's ideas of God power, unlimited power and affirmation were impressive and helped garner him a following.

Using a typewriter provided by Mr. and Mrs. Whitney, Floyd typed his letter with, it would seem, help from someone who had a better mastery of grammar and a flair for the dramatic.

August 18, 1944
Dear Mr. Robinson,

As the prophet of old said in his hours of trouble, "I am oppressed, O Lord! Undertake for me." I too, am in trouble and need your help. I have nothing to offer but my sincere belief that you can help me. In the following statements I shall try to state why I need your help. I am too young to have the experience that you have in dealing with the major difficulties of life so may I ask you to try to understand why I am calling on you. I have heard of your wonderful success in the field of guiding others to health and happiness so I, too, need that guidance.

Yesterday the State Supreme Court of this state denied me a new trial, confirming the sentence of the lower Court that I must die in the lethal gas chamber for having killed one A.H. Berning in 1942. At the time of this offense I was only fifteen years of age, and should I [have an] alibi I would say that I was not responsible, but, that alone would not suffice. I had been committed to an Industrial School in Indiana and had run away from there to avoid the physical punishment inflicted on the least provocation, therefore, when the gentleman in question stopped me for questioning I shot him rather than be subjected to what I thought would be a return to the living hell I had left. Instead of relieving the situation I made matters worse. I wish to make clear that I am not laying any blame on anyone except myself. Now that I realize the awful mistake I made I am asking that you intercede with the God-Power that I may have a chance to life and what happiness I can gather from the ruins of my past. As I stated above I have nothing to offer but my sincere belief that you and those you have so wonderfully helped can help me to another chance.

Dr. Robinson, any consideration given my humble pleas in my hours of distress will be greatly appreciated. May I thank you for the time and trouble expended in listening to my story and may I lean on you.

Most humbly yours,
Floyd Burton Loveless

Ten days later, Frank Robinson wrote to Governor Carville.

My dear Governor,

I do not know your name. I don't believe I need to. I receive many strange, urgent requests for help in the course of a year. Several similar requests to the enclosed have come to me, and, I am happy to say, I have been instrumental in saving more than one life thru a simple letter to the Governor of the State involved.

I know nothing about this case sir, I do know this boy is but 17 years of age. I know that my own son, a beautiful boy of 19 is flying a Torpedo Bomber far out over the Pacific Ocean tonight, doing his part to make justice and liberty safe for this war-maddened world. I trust he is also fighting for the element of mercy.

Governor—is there not some way in which the life of this young man can be reprieved? Could you not find it in your heart to grant him a reprieve? It's hard for one so young to die in a gas chamber—is it not?

I know the Laws must be upheld. But I also know that One, far greater than I said, long ago—"Though your sins be as scarlet, they shall be as wool." This young man has killed another man, and the Law demands his life. But Governor—you have the power to reprieve him. Won't you please do this?

If there is a way in which I can help, won't you please tell me what that way is?

Please let me hear that you have decided to save the life of this boy, whom I do not know, and have never heard of before. You will find a great satisfaction coming into your life if you will. Thank you for listening to me. Governor Bottolfson [sic] of our State can tell you about me if you need further information.

Cordially yours,
Frank B. Robinson

In response, Governor Carville replied:

August 29, 1944
Dear Reverend Robinson,

I want to thank you for the very fine letter you have written in behalf of Floyd B. Loveless, who has been sentenced to death in the Courts of the State of Nevada.

Undoubtedly a commutation hearing will be had in the near future by the Nevada State Board of Paroles and Pardons on Floyd Loveless' case. As Governor of the State of Nevada, I am chairman of this Board, but it would be impossible for me to give you any idea as to the decision of the board, or a possible decision of it, before the case is thoroughly gone over at the hearing.

You may be assured, however, that each member will be impressed with the seriousness of his decision and to the very best of their ability will show the greatest amount of justice possible.

Sincerely yours,
E.P. Carville, Governor.

True to Frank B. Robinson's word, the governor of Idaho C.A. Bottolfsen wrote to Governor Carville that same day:

August 29, 1944
Dear Governor Carville,

I am writing you on behalf of Frank B. Robinson of Moscow, Idaho, who has written regarding a 17 year old boy condemned to die in Nevada. I have known Robinson for a number of years and have always known him as a man looking out for the best interests of others. He has at all times looked toward the betterment of the community even though it meant personal expense to him. I do not hesitate to recommend him as one of Idaho's outstanding humanitarians.

I hope that this letter will better acquaint you with Mr. Robinson. I know that he is writing to you only because of his great interest in the welfare of others. With best wishes, I am

Yours very truly,
C.A. Bottolfsen Governor

Neither Wines nor Custer was surprised at the Supreme Court's decision denying a new trial for Floyd. Now they would have to put their final plan into action: a commutation hearing. September 29 was fast approaching. Without Floyd's signature on the application for commutation, his execution date would stand. Taylor Wines and Oliver Custer believed there was a good chance of having the boy's death sentence commuted. But he had to fight. As the days wore on, he seemed less inclined to do so.

Oliver Custer decided to take a chance. Instead of going to the office on Tuesday morning, August 22, 1944, he drove down to the state prison in Carson City. With the mandatory war speed limit in effect, the trip took nearly an hour. The time wasn't wasted. Alone in his car, Custer outlined the steps he and Taylor Wines would take for Floyd's commutation hearing. Promising himself to remain optimistic until the end, Custer steeled himself for his meeting with Floyd. He would be positive.

The teenager greeted him warmly. He didn't get many visits and was happy to see anyone from the outside, even an attorney he barely knew. The meeting lasted less than an hour. In that time, Floyd told Oliver Custer about his life back in Indiana and of losing his mother while he was still a toddler. He didn't remember her. It was too long ago. But he had always known that her death—and the secrets surrounding it—had somehow set him and his brothers apart from the other kids.

"I wanted to prove to the others that I could make good. Make something of myself." Floyd looked at the paper and fountain pen that Custer had taken from his briefcase.

"Both Mr. Wines and I believe you have a good shot at this Floyd—"

"No, I don't want to ask for a commutation, Mr. Custer. This is no life. I had rather die in the gas chamber than have to live in this place for the rest of my life."

"What does your family want you to do?" Custer asked.

"They want me to try, but—"

'Well, then, perhaps you ought to do it for them."

Custer had found his motivator. Floyd picked up the pen and signed the paper. "There's nothing here for me, Mr. Custer."

Custer was used to keeping his face an unreadable mask. Used to holding his emotions in check, nonetheless, he would think about the boy's words on the long drive back to Reno and for a very long time afterward.

When he returned to his office, he dictated the following letter to Taylor Wines.

Dear Taylor,

I have just returned from Carson City, where I had a conference with Floyd Loveless.

I have prepared an application for commutation of sentence and have left it with Mr. William Harris, the Secretary of the Board, with instructions to file the same immediately after the Court at Elko resentences Loveless, I think it is preferable to file it at that time rather than file it now.

I spent about forty-five minutes with Floyd and got his life story, which is a truly pathetic story. If he is executed, then the State of Nevada is punishing a child for the errors and omissions of his parents.

Floyd said that he did not want to ask for commutation and that he would rather die in the gas chamber than live in the State Prison for the rest of his life. He is just like any other confused child about the whole affair. I finally persuaded him to sign the application.

One of the deputy wardens at the prison, whose name I do not have, whom I have known for several years and found to be very reliable, told me that he had a talk with Judge Allen McFarland, Justice of the Peace at Elko, and that Judge McFarland took the same view of this case that you and I have taken and seemed very sympathetic toward the boy. The deputy warden also said that Miss Mary McNamara, the postmistress at Elko, is also sympathetic. I suggest that you talk with these people and if you think it advisable have them write letters to the Board of Pardons and Paroles expressing their views, or, if you believe you can get other persons in Elko County to sign a petition for commutation, that you see what you can do along that line.

As soon as Mr. Harris files the petition, he will call me by long distance and arrange for a date for the hearing with the board. I think it will be very important for you to appear before the Board and testify as a witness on behalf of Floyd Loveless. You can testify along the lines which we have heretofore discussed. I believe that the Board would let you testify orally; however, if they will not, then you can make an affidavit.

Mrs. White is circulating petitions asking for commutation at this time. I shall keep you advised of all developments. With kind personal regards, I am Sincerely yours.

OH, THE MOONLIGHT'S FAIR TONIGHT ALONG THE WABASH

Late Wednesday night, the phone rang at the Custer home. The news was not good. Oliver Custer's brother was gravely ill in a Georgia hospital. The family needed Custer to come to Georgia as soon as possible.

The next morning was Thursday, September 14, fifteen days before the Floyd Loveless execution date. Custer hurried up the stairs to his office. First, he would have Mrs. Parks make his travel arrangements, and then he must phone Governor Carville. He would also need to write to Taylor and let him know what was happening. He called the operator, gave her the governor's number and waited.

The conversation was friendly but brief. Governor Carville was, like Custer himself, a busy man. He put the phone piece down and wrote to Taylor Wines.

124

Dear Taylor;

Due to the serious illness of my brother, it is necessary for me to leave for Georgia tonight. I may be away from three weeks to a month.

I talked with Governor Carville this morning on long distance and asked him to grant a reprieve of thirty days to Loveless. In other words, to reset the date of execution for October 29, 1944, in order that I would be certain to have returned from Georgia to appear before the Board of Pardons and Paroles. Governor Carville advised that at this time he could not grant a reprieve for thirty days, but that if I would telegraph him upon my arrival in Georgia, advising him when I expected to return, that he would grant a reprieve of thirty days, if necessary. In other words, he assured me that he would grant a reprieve of a reasonable length of time in order that I could return to Nevada to appear before the Board. Of course, if I find that I will be delayed in Georgia for a long while, then he would not grant a reprieve, but would set the hearing on the application for commutation for September 22, 1944, or certainly on a day before September 29, 1944.

Due to transportation, it is impossible for me to know when I will arrive in Georgia, as it is three thousand miles to my destination. If it is impossible for me to return within a reasonable time, then I suggest that you wire Governor Carville and find out what the situation is and if he insists upon going ahead with the commutation hearing before September 29th and refuses to grant a reprieve, then it will be necessary for you to appear before the Board and plead for Loveless' life.

In that event, I suggest that you communicate with Judge L. O. Hawkins at Las Vegas by long distance and ask him to be present. Also, that you communicate with Mrs. Ed White of Reno and have her get Father Collins and all other interested parties to appear at Carson at the time set. Please emphasize in your communication with Mrs. White that she should bring all petitions which have been signed by various parties here. I regret that this has arisen, but I of course must go to my brother immediately. With kindest personal regards, I am sincerely yours.

George Wright, the Elko district attorney, was also gearing up for the Loveless hearing. On September 16, he wrote a lengthy letter to the board outlining Floyd's eighteen crimes. The eighteenth on his list was attempting to shoot it out with four armed officers. According to the testimony of the four men (Guidici, Goicoechea, Anderson and Aiazzi) who apprehended him, Floyd reached for his pocket when told to put his hands up. Floyd's gun, however, was not in his pocket but in a front waistband.

Wright wrote:

Gentlemen
Re: Application of Floyd Loveless

After a thorough study of the facts of the case of the murder of Officer A.
Berning on August 20, 1942 at Carlin, Nevada, by Floyd Loveless and
his past record and his conduct during the two trials, it is my unequivocal
opinion that he verdict of the jury and the death penalty is correct and the
sentence should not be commuted to life imprisonment. I feel that his conduct
since conviction is of little aid in determining the real merits of the matter.

HISTORY
The defendant was born on November 2, 1926 at Stockwell, Indiana.
Since that time we have records and the confession of the defendant showing
the commission of 18 major known crimes by the defendant, including
burglary, robbery, by striking a woman with a milk bottle, rape by the use
of a loaded revolver, attempting to shoot it out with four armed officers and
a cold blooded murder wherein the defendant shot an officer, took him away
from medical help and abandoned the officer to die...

(18) August 20, 1942, 4 armed officers stopped defendant who was
walking on the highway and after shooting of Berning. One of the officers had
his gun drawn and told defendant to put up his hands. Defendant started for his
gun but when told to put up his hands for the second time, complied-attempt.

When S.O. Guidici was asked by Taylor Wines, "Did he [Floyd] make any
threatening gestures?" Guidici testified, "No."

In describing the shooting of Berning, Wright wrote:

The facts show Officer Berning to have been shot without warning and without
a struggle. Berning could talk for over a day after he was shot and brought to
Elko General Hospital. We therefore know how the shooting occurred.

How could a right handed boy, smaller than Berning shoot Berning so
that the bullet entered directly from the front and traveled in a downward
course, if, as defendant claims, the officer was in the car and after a struggle
occurred? This is a physical impossibility.

We submit that defendant was in Indiana given a chance for rehabilitation
first probation and then Reformatory but the defendant was not amenable
to correction—he escaped one month after being in the reform school only to
commit one of the most cold blooded murders of this County and took the

126

life of a useful, well thought of citizen whose ability as an officer of the law was above reproach.

This state has a declared policy of capital punishment and until the legislature changes this policy, we submit that this policy should control.

Respectfully submitted
George F. Wright.

While Floyd's attorneys fought to save his life, another battle was taking place. A battle to save Floyd's eternal soul erupted on Saturday, September 16, 1944, when Reverend Frederick Busher attempted to visit Floyd at the prison in Carson City. Who would save the boy's soul? The reverend took umbrage at what he saw as a slight and promptly wrote to the Governor Carville.

Dear Governor Carville,

I had a rather strange experience which I wish to bring to your attention. I endeavored to visit the Loveless boy today, at the behest of some of the interested citizens of Reno, who told me [he] was a Methodist and wanted to see a Methodist minister. I certainly wouldn't waste gas and time without some sensible reason for a trip to Carson. However, I was told by Warden Sheehy that ONLY a Catholic priest could see the lad.

It has been my privilege to visit many State Prisons and offer spiritual comfort to the condemned and never has the question been raised about denominational ties. Ordinarily our public institutions are open to the ministrations of the clergy regardless of faith. I am sure the Catholic Fathers feel free to visit and help Protestant boys, and I have many times done likewise for Catholic prisoners. In this case, however, I went to Carson on the direct appeal from a Catholic lady, Mrs. Ed White, who claims to have a letter in writing from the boy to effect that he is of Methodist background and would like to see a Methodist Minister.

Regardless of the particular incident, however, it seems strange that a clergyman of a recognized church in the important city of a state should not at least be considered welcome in a public institution.

Sincerely
Reverend Frederick H. Busher

After a phone call to Warden Sheehy, Governor Carville wrote to the reverend.

September 21, 1944
My dear Reverend Busher,

Upon receipt of your letter of September 15th, I talked with Warden Sheehy in regard to the visit you made to the Nevada State Prison to see the Loveless boy.

It is my opinion that you have misinterpreted the conversation you had with Warden Sheehy as well as the Warden's policy toward denominational preferences of any prisoner. I know that the Warden and all of the attendants of the prison are always ready and helpful in obtaining spiritual aid for the inmates, through ministers and priests of the prisoner's particular faith or choosing. This is especially true in those cases where a man is condemned to death.

Floyd Loveless has been in the Nevada State Prison since October 7, 1942. A lady in Reno inquired from him some time ago what his religious faith was. He told her that his mother was a Methodist and I understand that this lady got in touch with you and suggested that you visit him. Several months elapsed and in the meantime, Floyd asked to see the priest who was visiting the prison. He was granted this request and has expressed his choice for the religion that this priest represents.

As the date for execution has been set, Loveless is in the condemned cell now. Any citizen of this State or any other State would easily realize that very strict rules must be observed in a prison and particularly for those people who are being held under a death sentence. It is possible to allow only those people who are close relatives, legal councils and a religious council to see condemned men. I am certain if you were to check with any prison in the United States, you would definitely learn that a condemned man is allowed to have only one minister or priest of his own choosing to visit him.

It is very possible had you visited Floyd Loveless when you first learned of the faith of his parents, that your services would be requested and continued visits would be expected and allowed.

I am sorry that you made the trip to Carson City and found that your services were not needed but I am more particularly concerned with the attitude you have taken after that visit.

There are no religious issues involved in affairs of the State. With particular reference to the Nevada State Prison, Warden Sheehy is a man of absolute fairness and with no prejudices. He would be the first to see that each man be allowed his own discretion in choosing his right to worship.

With kind personal regards, I am sincerely yours
E.P. Carville, Governor

With his scheduled execution twelve days away, Floyd continued to correspond with those who had shown interest in his situation.

Carson City Nevada
September 17, 1944
Dear Mr. and Mrs. White,

I received your letter this afternoon and I'm glad to hear from you. The Catholic Priest was just here. Probably next week I'll be baptized.
No ball game today. I don't think we'll have anymore [sic] *games this year.*
I heard from Mrs. Whitney day before yesterday. She is pretty busy. I sent her a picture like the one I sent to you. All my life I've liked to take pictures and have my picture taken.
I heard from my Grandmother too. She has been busy too. Dad and Grandma would come out here but Dad can't get the gas or tires. I think the trip would be to [sic] *much for my Grandmother anyway. Dad and my uncle (one of them) was out here in 1942 to see me.*
All I can say if I don't get a comute [sic] *that it is a good feeling while one's alive. You can't kick after you're gone. I have no hard feelings against anyone. What has happened has already put a different look on life. What I know of it. Life is a word with so much meaning. I have a lot to learn yet.*

Sincerely,
Floyd Loveless.

"Dad can't get the gas or tires"—Floyd may not have been referring to the family's lack of traveling money but to wartime rationing that included (rubber) tires and gasoline. Also discouraged was all nonessential travel. Visiting one's son in a penitentiary across the country was probably not considered essential.

Mrs. White read the sentence with disgust. No tires and gas were just an excuse for the boy's father. She could not understand how any parent, knowing his child was on death row, would not make every effort to try to save him or at least come to him and spend some time with him. If he truly wanted to see his son, the elder Loveless would get on a bus and come to Nevada.

She expressed her views in a letter to Governor Carville:

September 19, 1944
Dear Governor,

I am enclosing a copy of a letter to you which was mailed to me, I presume by the Methodist Minister—Yes I did ask this minister to go see Floyd Loveless. But that was quite a long time ago— Floyd Loveless told me his mother was of Methodist faith—so I told him if he wished I would sent this gentleman down to see him. But I did not know until the Warden informed me—a few days ago—that Floyd Loveless had asked for the Priest—over 2 months ago—when I asked Floyd what his faith was. I figured that a child condemned to die should have some religious faith to sustain him. I am glad and proud that he has asked for the Priest. Quite a while ago I started sending him extensive magazines. I also sent him a 4 Mary medal. But all his letters he never told me he was receiving Religious Training.

Ray Loveless with car. *Photo courtesy of Mike Loveless.*

I believe the dear Fathers who are so interested in him can really bring out what is best in him—and if his life is spared I give my word of honor before God and the Holy Mother to do my best to rebuild his life.

The father of this boy makes the weak excuse he cannot come to him because he cannot get gas and tires. He can travel by bus cheaper than he could drive his car. If it were my boy I would hitchhike to help him or at least be with him. So hoping for the best—and that your health is improving each day. I remain your friend.

Mrs. Ed White.

Just as on any usual Monday, the phone was ringing even as Mrs. Parks unlocked the office door.

"Good morning. Law offices Oliver Custer," she said breathlessly.

She listened to the man on the other end then said, "Thank you Mr. Sheehy, yes, I will let Mr. Stewart know." Royal Stewart was an assistant to Oliver Custer

who, along with Taylor Wines, would handle Floyd Loveless's commutation hearing. She replaced the receiver and grabbed for a pencil. No sooner had she started writing than the telephone rang again.

"Law offices Oliver Custer."

"This is Governor Carville calling for Mr. Stewart," he said.

"I am sorry, sir. But he is not in at the moment. May I take a message?"

Mrs. Parks listened intently. When the conversation was concluded, she wrote her notes.

> *Monday morning September 18, 1944 10 o'clock*
>
> *Mr. Sheehy of the state prison called. The Governor has set hearing for Floyd Loveless on September 26th at ten o'clock in the morning at the Governor's office.*
>
> *The Governor himself called later asking for Mr. Stewart. He talked to me. He is not sure that he can legally grant a reprieve. See Vol. 1, page 60, Nevada Compiled Laws, Section 99. He is getting a ruling from the Attorney General and will call me again. I told him about Mr. Custer's letter to Mr. Wines, and when the Gov. calls us again, we must get in touch with Mr. Wines.*
>
> *Mr. Stewart called Governor Carville has a ruling from Attorney General cannot grant reprieve.*

Her notes written, Mrs. Parks deftly placed a sheet of paper over a carbon paper and ratcheted them into her typewriter. She would inform Mr. Wines that Mr. Custer would not be back in time for the Loveless hearing. She stopped typing. A telegram would be quicker.

The *Carson City Chronicle* presented a much longer and different viewpoint than that of the Elko newspaper in its earlier editorial. The *Chronicle* of Friday, September 22, 1944, stated:

> *Open Letter to the Honorable Board of Pardons and Parole.*
>
> *Gentlemen: Today millions of our men and women, boys and girls, are engaging in a bloody war which is being waged for the maintenance of principles of Christian democracy.*
>
> *Today international society is paying a terrific price in human suffering, broken homes and the sacrifice of life for its neglect of past decades.*
>
> *Today we as parents, as educative factors, as nations and as a world-society are, through the youths we are educating and setting an example to, laying, the groundwork for the world society of tomorrow while we pay for the mistakes of yesterday.*

Today a lad not yet 18 sits in the "death house" of our state penitentiary awaiting the carrying out of his sentence.

He cannot be said to be languishing in his cell, for he has been applying himself to acquiring useful knowledge during these months since a death sentence has hung over his head and has, in that respect disclosed a rare quality of determination and courage. For to all intents and purposes his knowledge will never be of any value to him.

On Tuesday next you gentlemen are to decide whether Floyd Loveless shall live or die.

On Tuesday you will carefully review the facts that Floyd Loveless committed a major crime in Nevada; that he is evidently a reprehensible character; that the probability of his becoming a good citizen is remote or imminent.

You will issue an edict which will either commute him to life imprisonment or condemn him to the gas chamber.

As in cases of the past, you have a terrific responsibility to the people of the state, to the nation, to yourselves, and to the upholding of the principles over which the world is today fighting.

We do not envy you. Rather we commend you upon your decisions of Tuesday as well as those in the past, for we know that regardless of the outcome, that decision will be in accordance with your views of our welfare and in just fulfillment of the responsibility placed upon you.

We know you have carefully weighed the facts of the Loveless case—or will have—so we do not attempt to offer to call any facts to your attention.

We do, however, take occasion to emphasize a few highlights of which we are aware and ask that you give these special consideration

Floyd Loveless has not had the privilege of being brought up under normal circumstances; he has not had the advantage of a normal home life and the care of a loving mother.

As a probable result of these facts he was at an early age committed to a reform school and while still in his fifteenth year escaped and started west.

Because he was caught up with; because he sensed the frustration of his questionable ambitions; because he was afraid of being made to return to the environment he had left, he killed a man.

Loveless is a nice-looking boy. He is still less than 18 years old; he has a good personality; he has many good habits; he has not evinced the traits of most men in his position; regardless of statutory provisions he was a mere boy when he committed his crime.

The possibility exists that given a reasonable opportunity Floyd Loveless can become a useful citizen; he is still quite young and quite impressionable

and it is possible that his experience may result in a reaction beneficial to himself and to society.

Should you see fit to commute his sentence, gentlemen, you do not turn him loose again upon society. You do give him an extended opportunity to "show the stuff he is made of."

Should your decision prove erroneous after a 7 year period, he will merely share the lot of other "lifers" in the penitentiary, and the state will be no worse off.

Should your decision be justified you will have expressed Christian principles not provided for by statute and at the same time converted a bad boy into a good man.

In closing we quote from Matthew 5:44 "But I say unto you. Love your enemies, bless them that curse you, do good to them that hate you, and pray for them that despitefully use you and persecute you."

These are the words of our exemplar Jesus Christ, and in his name we pray that the principles laid down by him be expressed in the hearts and lives of all mankind.

Again we commend you upon whatever your decision may be and respect you for it. But we hope and pray that you may be guided to give this boy a chance to become a man.

September 22 promised to be another warm day in Carson City. Indian summer is what the locals call that time before colder temperatures settle into the region, a comfortable lull between summer's heat and the gloom of winter. This was the day of Floyd Loveless's commutation hearing before the Nevada Board of Parole and Pardons, the day on which all the youngster's hopes hung.

Every chair was taken. A soft murmur echoed throughout the room. People, eager to share their views on whether the seventeen-year-old should receive a commutation, talked among themselves and waited. The Board of Paroles and Pardons was made up of the three Nevada Supreme Court justices, the state attorney general and Nevada governor E.P. Carville, who also acted as the board's chairman.

Carville called the special meeting to order. The board would now decide the fate of Floyd Loveless.

Taylor Wines rose to speak. Reminding them that Floyd had been only fifteen when Berning was killed, he asked that Floyd's youth be taken into consideration. Because Oliver Custer was still in Georgia on family emergency, his assistant, Royal Stewart addressed the board next.

"Please give this boy a chance in life," he urged. "It will be the first he has had since birth. The fault here is hereditary. He is only seventeen, gentlemen. Please consider his age. If he should be executed, it will be for the crimes of the parents."

"Mr. Wines, what are your future plans for Floyd Loveless if he should be given a commutation?" Deputy Attorney General W.T. Mathews asked.

Before Wines could answer, Elko district attorney Wright asked, "Isn't it true, Mr. Wines, that Loveless said if the jury found him guilty he had rather be gassed then spend his life in prison?"

"No," Wines answered sharply.

Reno High School student Scott Whitney's parents had befriended Floyd and corresponded with him regularly. Young Whitney spoke on behalf of his contemporary, asking that the board not punish Floyd Loveless so harshly. When he was finished, Whitney presented two petitions signed by students of Reno High School and Sparks High School.

Father Collins of the Catholic Welfare Society told the board that the punishment was unjust.

Elko district attorney Wright began his argument against commutation by talking about Officer Berning's dying statement. The statement was excluded from the records. The board ruled there was no question of Loveless having killed Berning; his attorney had not denied his guilt. After talking about Floyd Loveless's extensive criminal record, Wright read that record to the board.

Floyd Loveless had not been charged with, or convicted of, the rape of Mrs. Knoth. There was not enough evidence, and the victim herself could not positively identify him as her assailant. And yet they argued over the crime. Wines stood.

Floyd, he told them, was known to sometimes take the blame for crimes of his brother and friends. It was more likely that his confession had been an attempt to protect his elder brother Robert.

Wright then argued that infants were not immune to the death penalty. And according to the handwritten meeting record, he cited many cases in which children twelve years of age were executed.

The written record does not mention if Wright brought up the name George Stinney. Stinney was executed in South Carolina on June 16, 1944, at the age of fourteen, making him the youngest person to be executed in the twentieth-century United States. Nor did Wright refer to the twelve-year-old girl Hannah Ocuish, who was hanged in New London County, Connecticut, on December 20, 1786. He also did not refer to James Arcene, the youngest person ever to be sentenced to death in the United States. Arcene was eleven

when sentenced and twenty-three years old when his execution was finally carried out in June 1885.

In the "Supplemental Points and Authorities of the District Attorney, Elko County, Nevada" that he presented to the Pardons and Parole Board, Wright wrote:

INFANTS ARE NOT IMMUNE FROM DEATH PUNISHMENT
In the case of The State v. Guild, *10 N.J. Law 163, 18 Am. Dec. 404, the defendant was 12 years and a little over 5 months old at the time that he killed a woman by beating her about the head and body. He hit her four times. The jury returned a verdict of guilty which carried a death penalty. An appeal was taken. The case affirmed and the defendant executed.* [The boy was hanged. What Wright did not mention was that the defendant, Guild, was a slave and that his case predated the Civil War.]

The Board of Pardons and Parole do not impose the death penalty. The jury did that and the trial judge carried out the mandate of the jury. The duty as to commuting a sentence is negative in character. As stated in the case of Henry v. State, *Okl. 1. 136 F. 982 at 988 (a state where the governor has the power of commutation).*

There is no provision of law in Oklahoma which requires the Governor to approve a verdict assessing the death penalty before it is executed. His duty with reference to such verdicts is negative and not affirmative. He has nothing whatever to do with them, unless he may be satisfied that an injustice has been done in an individual case; then he may commute the sentence or pardon the offender; but this can only be done upon the ground that, upon the facts presented, the defendant was a fit subject for executive clemency, and that an exception should be made in his favor as against the general rule of law.

We submit that the verdict of the jury was not the result of prejudice or passion but was based on facts and an injustice has not been done and the Board of Pardon and Parole should deny the request for commutation to life imprisonment.

Respectfully submitted
George F. Wright
District Attorney.

This is contrary to the August 22, 1942 *Reno Evening Gazette* account of the community's feeling about the crime.

District Attorney C.B. Tapscott was searching the Nevada statutes to determine how best to proceed against the youths....He said he intends to demand the maximum penalty for both boys, and Elko county residents, in high feeling since the shooting say they will insist on the full penalty for Loveless regardless of his age....Observers said that the community of Elko has not been so aroused since Luther Jones shot four prominent Nevada stockmen to death in a cabin at a cattle corral near Elko in 1936.

In trying to save Loveless, L.O. Hawkins also ignored the execution of George Junius Stinney that year. Apparently Stinney was executed after the case Hawkins referred to in the following telegram he sent to the Governor Carville, chairman, on the night before the hearing.

In Ridge against state 229 Pacific 650 Oklahoma supreme court say quote in all the history of our law there are few instances where young children have been put to death as a punishment for murder and none anywhere so far as we know within the last years unquote hope Loveless life we be spared. LO Hawkins.

Elko County sheriff C.L. Smith told the board about reading a letter that Floyd had written to his grandmother while in the Elko jail. According to Smith, Loveless had complained that the majority of Elko spoke for Elko County and the prison groups should do something more than to save the lives of criminals.

His feelings seemed to be shared by Mr. Griffin of Carlin, who said, "Two times is enough. Now the state should carry out the law."

Mr. and Mrs. Thomas spoke of Loveless's extensive record and how they felt he should not be given commutation.

Royal Stewart spoke again in rebuttal; when he was finished, it was noon. The meeting was adjourned for lunch until 1:30 p.m.

When the meeting resumed, Attorney General Alan Bible read petitions and several of the letters written by Floyd's friends and family.

Inmates of the Nevada State Prison had drawn up their own petition that was signed by 161 of them. The petition was also presented and read to the board.

We the undersigned do hereby beseech, and beg, of the honorable Board of Paroles and Pardons that they give their careful consideration to this petition.

We are making an appeal on behalf of Floyd Loveless, sentenced to be executed on the 29th day of this month.

We have been associated with Floyd since his incarceration here, and we believe that this young boy (only 15 years at time of crime) should have his sentence of death commuted to a life sentence. He has been extremely popular with all the inmates here and with the prison personnel has never given any of us any trouble and has been nothing but honest to all of us.

To take the life of the young boy would not benefit anyone, two wrongs will not make a right and to execute this boy would be against God's law, who put breath into all living things.

So again, we beg that you listen to our pleas, AND SHOW MERCY TO FLOYD LOVELESS

September 9, 1944
To the Honorable Board of Pardons and Probations
Gentleman:

Whereas one Floyd Loveless is now in the Nevada State Prison, at Carson City, under sentence of death for the murder of one A.H. Berning committed in Elko County, Nevada on August 20, 1942, and will shortly be executed at said State Prison unless your Honorable Board commutes his sentence; and

Whereas the said Floyd Loveless, at the time he shot and killed the said Berning was then only a boy between fifteen and sixteen years of age and has not yet attained the age of eighteen years; and,

Whereas, we believe it will be for the best interest of society and act of Christian mercy to spare the life of the said Loveless; we, the undersigned, residents of Las Vegas, Nevada, therefore petition your Honorable Board to exercise the authority vested in you by the Constitution of Nevada, and the laws of this State, to spare the life of the said Floyd Loveless and commuted his punishment for said crime from that of death in the lethal chair to life imprisonment. Respectfully signed and submitted.

A Las Vegas lawyers' group also signed and submitted a petition for Loveless: "WE, the undersigned citizens of the state of Nevada, and the U.S.A. respectfully petition the Honorable Board of Pardons and Paroles to commute the sentence of Floyd Loveless from death to life imprisonment."

Among those who signed the petition were a local sheriff and the prominent Nevada lawyer and politician George Springmeyer, who also signed for his wife, Sallie R. Springmeyer. George and Sallie R. Springmeyer were the parents of famous Nevada author Sally Zanjani.

Floyd Loveless's statement to the board was also read aloud: "When Mr. Berning got in the car with me, we began to struggle and I shot him because I was frightened. I did not intend to kill him. At the time of the struggle I was 15 years of age. I am sorry for what happened and I did not mean to do what I did."

It was well into the afternoon; everyone had spoken, and the petitions, statements and letters had all been read. The time had come for the five members of the board to cast their secret votes. This was as far as it went. Taylor Wines and Royal Stewart exchanged worried glances. The hope that the young attorneys clung to was on the slenderest of threads. The room fell silent. The vote was announced: 3–2 against commutation.

Given that three members of the board were the same three justices who denied his appeal, this should not have come as a surprise. It is most likely that they are the three who voted against commutation and that Governor Carville was one of the two votes for it.

On September 28, 1944, Floyd was scheduled to die the next morning while most of Carson City slept. His case had garnered a lot of interest; news media was at the prison to get his last thoughts. Not shy about writing to well-wishers, family, friends and attorneys, Floyd had no words for these strangers with their pencils and notepads. He had always kept things to himself. Why should this be any different? His letters were written. Long letters in which he expressed regret and asked his family's forgiveness for all the pain he had caused.

In the warden's office, he was invited to sit down as he went over his final instructions. They were simple. He handed his packet of letters to Warden Sheehy; they were letters for the family and for the people who had fought so hard to prevent this night from ever happening.

"Warden Sheehy, will you see that these are mailed?"

Sheehy nodded. "I'll do that."

"And I want my stuff to go to my buddy Tom."

Sheehy looked at the boy who sat across from him. How on earth had this come to be? "Yes, I'll see that Tom gets your things, Floyd."

"None of them have the money to bring me home, so…I'll be—at the Catholic Cemetery here."

"I see," Sheehy said. "Is there anything else you'd like me to do for you?"

Floyd thought a moment. "Please send some roses to my grandmother."

When they heard about this, newspaper editors seized on the pathos in these words. This is something they could tell their readers. The *Reno Evening Gazette* from September 27, 1944, reported the details of the execution: "The

execution will be held at 5 A.M. at the state prison in Carson City, Warden Richard Sheehy announced today. Witnessing the execution will be peace and prison officials and newspapermen. Women are forbidden to attend."

In Indiana, Floyd's family still clung to the belief that no state would kill a child. Maybe Nevada wanted to frighten the boy; maybe the state would punish him by keeping him in prison at hard labor for the rest of his life, but surely it would not send a seventeen-year-old to the gas chamber.

Floyd had never come so close to death and never so close to the gas chamber. This time, he resigned himself. Preparations were underway for the early morning execution in Carson City when the phone call came. The execution was to be stayed until 6:00 p.m. so that the Nevada Supreme Court could consider a writ of habeas corpus. Attorneys Bert Goldwater and Royal Stewart presented the petition for a writ before Justice E.J.L. Taber.

Floyd waited, prayed, cried and wished with all his heart it could be different. His life was in the hands of three old men at the Supreme Court. What would they rule, he wondered. The way his life had been, he tried not to think of that, focusing instead on what Father Buel was telling him. A better place, that was where he was headed if they said no to his attorneys. If only he had listened to his grandmother, he thought. What was she doing at that moment?

The writ of habeas corpus maintained that Floyd Loveless was insane and did not have the capacity to understand the proceedings against him or to aid in his defense. And that his court-appointed attorney (Taylor Wines) failed to have Loveless examined by competent medical authorities and failed to present Floyd's true condition to the court and the jury.

The writ also stated that during the entire period of Floyd's trial, a large part of Elko County residents, from which the jury was drawn, were inflamed with passion, prejudice and bias against Floyd Loveless and that the juries impaneled were likewise prejudiced by passion and were biased; thus, Floyd Loveless was denied due process under the law, the constitution of the State of Nevada and the Fourth and Fifteenth Amendments of the Constitution of the United States.

The writ's last argument is as follows:

(e) That said action wherein said Floyd Loveless was convicted, was prosecuted on the part of the State of Nevada by one George Wright, an attorney at law of the State of Nevada; that said George Wright was not at the time said action was tried and appeal taken, a duly qualified or acting District Attorney or Deputy District Attorney of the County of Elko, or of

the State of Nevada, as made, provided and required by the statutes of the State of Nevada; that said prosecution by said George Wright was illegal and in violation of the due process clauses of the Constitution of the State of Nevada and the Constitution of the United States.

The Supreme Court of Nevada disagreed with this final argument. And the petition was denied with the following:

IN CHAMBERS PRESENT: Ho. We. E. Orr, C.J.. and Hon. E.J.L. Taber, J.
A petition for Writ of Habeas Corpus and Stay of Execution having been filed in the above entitled matter and submitted to Court for consideration and determination and the Court having duly considered the said application and being advised in the premises it is ordered that the petition be denied and a stay of execution refused on the grounds and for the reason that the said petition does not state facts sufficient to warrant the issuance of the writ prayed for. Done at Carson City, Nevada this 29th day of September 1944.

AN EYE FOR AN EYE

And strange it was to think that he
had such a debt to pay.
—Oscar Wilde, "Ballad of Reading Gaol"

It was over. Word was sent to Warden Sheehy; the execution would proceed. The mood at the prison turned gloomy. Inmates and guards spoke in hushed tones. Everyone liked the kid from Indiana who had gotten himself into a jam he couldn't get out of.

Work resumed in the gas chamber. As was legally required, Warden Sheehy had already sent out official invitations for the execution of Floyd Loveless. Except for four men from Carlin, no one would come. So it fell to prison guards, the prison purchasing agent and the janitor to watch what others would not.

With the legal fights all lost, there was nothing more to do.

In the condemned cell, Floyd was more scared than he had ever been in his life. Did it hurt to die? Father Buell had told him that he would be going to a better place, and he believed that. There was nothing else to believe in, nothing left for him in this life. His spiritual advisor, J.C.

MacCaffrey, came to see him. They talked awhile, assuring one another that they would one day meet again in eternity. They said their farewells, and MacCaffrey left.

Floyd was alone. There was an everlasting eternity waiting for him. Father Buell came next. And then, it was time. He had long ago promised himself that if this day ever came, he would not cry. Even as they came for him, even as Father Buell followed along with him and the guards, he would not cry. It was a solemn procession to the gas chamber. They stopped at the doorway. Only he would enter. They were not going where he was going, not tonight.

Any last words? No. What could he say now that he hadn't already said? He stepped in. Trembling, he sat down in the strange metal chair and watched as two men deftly tightened leather straps around his wrists and his ankles so that he couldn't escape. But where would he run?

"It happens pretty fast," one of the men assured him. "They say it's much easier if you inhale deeply when you hear the pellets drop," he told Floyd matter-of-factly.

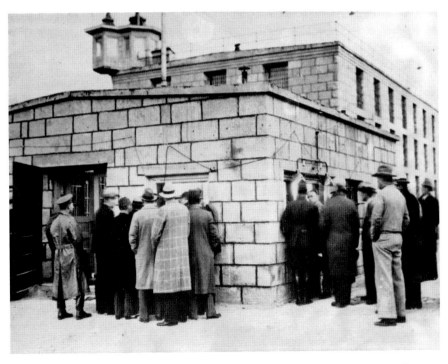

Witnesses to an execution stand outside the gas chamber at the Nevada State Prison in 1932. *Author's collection.*

Floyd nodded and glanced through the viewing window; most of those who stared back at him were prison employees. Some were cold-eyed strangers. He would never know that the four men had come all the way from Carlin to speak against his commutation and to watch him die, to see the justice for the killing of a friend.

A stethoscope was attached to him so that the doctor outside the chamber would know when death occurred. He may have been curious, but he didn't ask about it. What did anything matter now anyway? At seventeen years old, there was so much about life he didn't know, so much he would never know. Beyond the prison walls, the sun was slipping behind the Sierra. It was dinnertime for most people in Carson City. Back in Indiana, it was closer to bedtime. Was anyone in the family thinking about him?

Their work completed, the men stepped out of the chamber, sealing the door tightly behind them. He was going to die. And there was nothing anyone could do for him. His heart was pounding. Would it hurt? He wished he could go back to Plainfield and start over. It was so quiet in here, sealed away. He could feel his heart pounding in his chest; he could almost hear its beating.

He didn't see Warden Sheehy give the signal, but he heard the pellets drop. They made a fizzling noise. Then, he could smell them. He took a deep breath. "Holy Mary, Mother of God, pray for us sinners now, and at the hour of our death…"

His heart was still beating, but he no longer heard it, nor could he hear the whirring fans that sucked the noxious fumes out into the night air. Those who had watched him die silently shuffled out of the viewing area.

Welcome to Stockwell sign. *Photo by Bill Oberding.*

When it was safe, all the deadly gas expelled from the chamber, attendants went in and removed the body.

There are certain protocols involved with an execution. In 1944, in addition to the six witnesses, state law required that a physician be present to observe and record the death. Dr. G.H. Ross kept the following written record of Floyd Loveless's execution:

Prisoner entered chamber	*6:22 p.m.*
Strapped to chair	*6:24 p.m.*
Door closed	*6:26 p.m.*
HCN gas rose to face	*6:28 p.m.*
Apparently unconscious	*6:29 p.m.*
Heart stopped beating	*6:29 p.m.*
Certainly unconscious	*6:30 p.m.*
Respiration stopped	*6:30 p.m.*
Blower started	*6:40 p.m.*
Body removed from chamber	*6:59 p.m.*
Death announced	*7:00 p.m.*

On the Banks of the Wabash Far Away

In Indiana, Floyd Loveless's family watched their clocks and waited. They held out hope until the end. "None of us thought any state would do that to a child," Nettie Loveless wrote to Warden Sheehy in a letter dated October 12, 1944.

By 9:30 p.m., they knew. Floyd was gone. He was just too young to die. Older and wiser now, Ray Loveless couldn't change the past any more than he could bring Floyd back to life. But he could bring him back home to Indiana.

At the Western Union office, he scribbled out the form and handed it to the telegraph operator: "To Warden Carson City Penitentiary Please send Floyd Loveless remains to L.B. Loveless Stockwell Indiana. R.C. Loveless."

A return telegram explained that there would be a fee involved in shipping the body to him: eleven dollars and some cents.

The next day, Ray Loveless wrote back: "To Richard H. Sheehy I will pay transportation charges when remains arrive at destination. R.C. Loveless."

Floyd Loveless was yesterday's news. Still, the *Reno Evening Gazette* had something to say about the execution in its September 30, 1944 editorial:

A 16 year old youth is not too young to be held accountable for his actions. Loveless was as mature as thousands of boys now in the armed services. And this youth's record indicated that he was an incorrigible criminal, past rehabilitation. This was a tragic story—one which can carry no satisfaction to anyone—for it reflects some failures on the part of society, pitiful blemishes in the youth's early environment.

Darkness was spreading across the night sky. A hearse pulled up to the train station, and a coffin was quickly removed and loaded on board. The train rolled out of Carson City, heading north across Washoe Valley toward Reno, where its cargo was loaded onto an eastbound train. Just as sunlight lit up the Ruby Mountains, the train, its whistle screaming, rolled through Carlin, then Elko and on toward Indiana.

LOOSE ENDS

Carson City, Nevada
Oct. 1, 1944
Dear Mrs. Loveless,

The enclosed news clipping from the Reno Gazette will explain the passing of your Grandson Floyd Loveless who died here on the night of September 29, at 6:30PM.

You will also note that Floyd had embrassed [sic] *the Roman Catholic Faith shortly before he died. In fact I was his spiritual sponser* [sic] *(or God Father) at the time of his baptism, which was conferred upon him at his own request by the Rev. Fr. H.A. Buell of Gardnerville, Nev.*

The story of his conversion to Catholicism is as follows: An inmate pal of his by the name of Frank R. Black, who is also a Catholic, introduced him to the doctrines of that religion and after attending the services conducted every week for these who wish to attend them, Floyd himself asked the attending Priest for instructions which were gladly given him.

The change of attitude which took place in him after his conversion was a source of delightful amazement to everyone who knew him. He was not only heartily sorry for what he had done; but forgave all those whom he had formerly considered enemies. He also had such complete confidence in this

new gift of Faith in God that he looked forward to where he was going as a pleasant journey into an eternity of happiness.

In accordance with the instructions received from his Father, the remains were shipped from here last night, (September 30th) to Lafayette, Indiana and ought to arrive there about noon this coming Tuesday October 3rd.

Having died with all the religious rites of the Catholic Church, Floyd Francis (he took the latter name at Baptism) is entitled to a Catholic Burial. So if this rightful privilege is agreeable to you and his Father, then all you have to do is see the Pastor of the most convenient Catholic Church in Lafayette, and they will gladly conform with your wishes.

Rest assured that no matter what Floyd may have been guilty of during his lifetime, he died a good God fearing Christian. His child-like simplicity and sincere faith in his religious convictions was something to be marveled at. I talked with him an hour before he passed on; and the cheerful, smiling farewell with which he greeted me was a scene I shall never forget. With kindest regards, I remain most sincerely,

J.C. MacCaffrey

Four days after Floyd Loveless was executed, the train bearing his body pulled into Stockwell. He was home. It was a somber, gray day that gave way to rain as the casket was being unloaded for a final journey. It was still raining when friends and family gathered on Thursday afternoon for a funeral at the home of his paternal grandparents, Nettie and Leonard Loveless.

They were Methodists. His would be a Methodist funeral. After a brief sermon by C.V. Roush, pastor of the Stockwell Methodist Church, pallbearers (all Floyd's relatives) carried the casket to an awaiting vehicle.

At the Fairhaven Cemetery in Mulberry, friends carrying flowers joined Floyd's father, stepmother, grandparents and other relatives as they followed the casket to the graveside. Floyd would be laid to rest beside his mother in the family plot of his maternal grandparents, Assaba and Abbie Frey.

Indiana winds were stirring. Raindrops pelted the handful of mourners who had braved the weather and come to Fairhaven. Some of them may have remembered another day, not so long ago, when they all gathered here to bury Hazel Belle and three little boys fidgeted unhappily while their elders stood silent in their grief.

Fourteen years had come and gone. Nettie blinked back tears. She would forever remember her grandson as the little boy who only wanted someone to love him. Surely he was in a better place now. Her husband touched her gently on the shoulder. She had done all she could do for Floyd. The mourners scurried back to their cars.

Across the county from Mulberry, Richard H. Sheehy, the warden of the Nevada state prison sat down at his desk. He glanced out the window; the prison yard stood in the golden glow of late afternoon sunshine. The task before him was something he didn't relish. All along he thought Floyd would get his commutation. He would never understand, but Sheehy was a professional. As such, he had a job to do. What he wrote would be succinct and strike a balance. It must have just the right tone. Sheehy stared at the stack of blank papers and then ratcheted one into position on his typewriter. He thought a moment and started typing.

October 2, 1944
Dear Mr. Loveless,

Enclosed is a letter which your son, Floyd handed me to mail you on September 29th. He instructed me to mail some of his personal effects to his grandmother which I have done today.
 Should you wish any information of any kind please feel free to call upon me.

Very sincerely yours,
Richard H. Sheehy
WARDEN

October 2, 1944
Dear Mrs. Loveless,

I am mailing under separate cover a small package of personal effects your grandson, Floyd asked me to send you. He also asked me to send you any money that he had in his account. Accordingly you will find enclosed a check in the amount of $12.06
 Should you wish information of any kind regarding Floyd please feel free to write me at any time.

Very sincerely yours,
Richard H. Sheehy.
WARDEN

October 2, 1944
Dear Mr. and Mrs. Whitney:

Enclosed you will find the letters which Floyd Loveless gave me to mail to you on September 29th. I know that he sincerely appreciated all your efforts on his behalf.

Thanking you for your interest in Floyd, I remain,

Very truly yours,
Richard H. Sheehy
WARDEN

ALL SAID AND DONE

Two weeks would pass before Nettie Loveless responded to Warden Sheehy's letter.

October 16. 1944
Dear Mr. Sheehy,

I received your letter with the check of my grandson, Floyd's money. Today I received the package of his personal effects.
 There is one thing we would like to know about Floyd, maybe you can tell us. Did Floyd think we would have him brought home to be buried? We wanted to write and tell him we would but we hated to write and discourage him. Up until the last day we didn't think any state could do such a thing to so young a boy.
 He always wrote of you and so many out there being so kind to him. I haven't felt like writing before, but I wish to thank many times for your kindness to Floyd and for you courtesy to me.

Most Sincerely
Mrs. L.B. Loveless, Stockwell, Indiana.

Sheehy had a choice. He could withhold what he knew and spare the family or tell them the truth. Being a man of integrity, he pondered the question before responding. On the October 25, 1944, he wrote:

Dear Mrs. Loveless,

In reference to your letter of October 16, 1944, [I] would reply that Floyd understood that he would be buried in the local Carson City Catholic cemetery. He mentioned to me that the expense would no doubt be too great for you to do anything about him.

I was very glad to read in your letter that he considered that the personnel of this institution treated him kindly. Should there be any further questions you desire to ask please feel free to write to me any time.

Most Sincerely yours,
Richard Sheehy, Warden

Death sentences would continue. And so would the necessary paperwork showing that punishment had been meted out. Six months after Floyd Loveless's execution, Warden Sheehy filed the warrant of execution. He had done his job; he had overseen the incarceration and carried out the death sentence.

RETURN OF WARDEN ON WARRANT OF EXECUTION
Filed March 26, 1945

TO THE HONORABLE JUDGE OF THE FOURTH JUDICIAL DISTRICT COURT OF THE STATE OF NEVADA, IN AND FOR THE COUNTY OF ELKO

I, Richard H. Sheehy, warden of the Nevada State Prison at Carson City, Nevada, do hereby certify that I received the warrant of Execution dated September 8, 1944, and the body of Floyd Loveless having been delivered into my custody on October 7, 1942, by C.L. Smith, Sheriff of Elko County, State of Nevada. I further state that, pursuant to law, I invited a competent physician and not less than six reputable citizens over the age of twenty-one years, to be present at said execution. I further certify that I kept and detained said Floyd Loveless, in close confinement at the Nevada State Prison, at Carson City, Nevada, until the twenty-ninth day of September 1944, at 7:00 PM. At the time of 7:00 PM on September 29, 1944, within the walls of the said State Prison, at Carson City, Nevada, I executed the judgment of the above entitled Court, by then administering to the said Floyd Loveless a sufficient quantity of Lethal Gas to cause death. I further certify that I was present at said execution and that there was also present a competent physician and six reputable citizens, over the age of twenty-one years.
Richard H. Sheehy, Warden
Nevada State Prison
Carson City, Nevada

Epilogue

Life went on. Oliver Custer continued to practice law in Reno for several years after the Floyd Loveless case. Judge James Dysart died suddenly at his Elko home on September 11, 1945, less than a year after Loveless's execution.

Some of those who'd fought so hard to save Floyd Burton Loveless life were bitter. Mrs. White wrote to Oliver Custer on January 2, 1947:

> *I never met such a bunch of four flushers as I met in Reno after I tried to help that kid. All they are all looking for is prestige and glory. The Editor of the* Journal *in Reno told me he wanted to write up the Loveless case and you told him the case was getting along very well with out him....Old Judge Ducker the Supreme Court Justice of Nevada who voted to*

Author with Stockwell historian Thelma Brooks Morgan. *Photo by Deborah Carr Senger.*

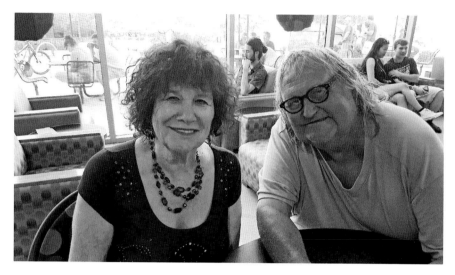

Author with Mike Loveless. *Photo by Deborah Carr Senger.*

execute that boy went to meet his reward. I hope Floyd was on the receiving committee. The people of Reno are all sold out to the gambling and vice element that they do not dare to do anything decent for fear of ruffling old man Smith's feelings—the whole town preachers and all are sold out to Harold's Club. Even the university has sold out to Smith [the writer was referring to Harold Smith Sr., owner of Harold's Club, one of Reno, Nevada's earliest and most popular casinos]. *He will be telling them next, who can attend and who cannot.*

Taylor Hood Wines became the district attorney in Elko in 1945. Like Oliver Custer, he would forever remember Floyd Loveless. In 1948, while presiding over the case of David Blackwell, an eighteen-year-old who had shot and killed two Reno police officers, Judge Wines removed himself on moral grounds. He felt strongly that there should be no death penalty for youthful offenders. Blackwell was executed on April 22, 1949.

Former district attorney Wright, who fought to send Loveless to the gas chamber, went into private practice in Elko. In 1948, Wright's client Laszlo Varga appeared before Judge Taylor Wines for the vicious murder and rape of a minister's wife. Wright argued that since Lazlo was probably eighteen, not nineteen, his case should be heard in juvenile court. Wines disagreed. Lazlo was found guilty and sentenced to death. He was executed on June 7, 1949.

Elko district attorney C.B. Tapscott, who convicted Loveless in 1942, went on to become a Nevada deputy attorney general. Governor Carville

resigned in 1945 and was appointed to the U.S. Senate to fill the vacancy left by the death of James Scrugham. After serving two years, the former governor practiced law in Reno until his death in 1956. Taylor Wines retired to California, where he died in 1986.

On June 29, 1972, the U.S. Supreme Court found the imposition of the death penalty to be cruel and unusual punishment in violation of the Eight and Fourteenth Amendments.

The landmark decision was decided on a vote of 5–4. The moratorium on the death penalty ended four years later with the *Gregg v. Georgia* decision, in which the court sided with Georgia, upholding new death penalty statutes; the death penalty did not violate the Eight and Fourteenth Amendments.

The re-implementation of capital punishment resumed with the execution of Gary Gilmore on January 17, 1977, in Utah. Gilmore died by firing squad.

In 1983, Nevada adopted lethal injection as its method of execution.

In 2005, the U.S. Supreme Court held that it was unconstitutional to impose capital punishment for crimes committed while under the age of eighteen.

Writing for the majority Justice Kennedy stated:

> *When a juvenile commits a heinous crime, the State can exact forfeiture of some of the most basic liberties, but the State cannot extinguish his life and his potential to attain a mature understanding of his own humanity...*
>
> *Retribution is not proportional if the law's most severe penalty is imposed on one whose culpability or blameworthiness is diminished, to a substantial degree, by reason of youth and immaturity.*

Bibliography

BOOKS

Beineke, John. *Hoosier Public Enemy: A Life of John Dillinger*. Indianapolis: Indiana Historical Society Press, Eugene and Marilyn Glick Indiana History Center, 2014.

Bentley, Amy. *Eating for Victory: Food Rationing and the Politics of Domesticity*. Champaign: University of Illinois, 1998.

Capace, Nancy. *Encyclopedia of Nevada a Volume of the Encyclopedia of the United States*. Santa Barbara, CA: Somerset Publishers, 2001.

Carrillo, Juanita Karen. *African American History Day by Day*. Santa Barbara, CA: ABC-CLIO, 2012.

Cavinder, Fred D. *The Indiana Book of Records, Firsts and Fascinating Facts*. Bloomington: Indiana University Press, 1985.

Cohen, Stan. *V for Victory: America's Home Front During World War II*. Missoula, MT: Pictorial House Publishing, 1991.

Emmons, Nuel (as told to). *Manson in His Own Words*. New York: Grove Press, 1986.

Hall, Shawn. *Old Heart of Nevada: Ghost Towns and Mining Camps of Elko County*. Reno: University of Nevada Press, 1998.

Hegne, Barbara. *The Hanging of Elizabeth Potts: The Only Woman Ever Legally Hanged in Nevada*. N.p.: self-published, 2005.

James, Ronald M. *County Courthouses of Nevada: Temples of Justice*. Reno: University of Nevada Press, 1994.

Lingenfelter Richard E., and Gash Karen Rix. *The Newspapers of Nevada: A History and Bibliography 1854–1979*. Reno: University of Nevada Press, 1984.

Morgan Brooks, Thelma. *Loveless Family: A Brooks Morgan Project*. Stockwell, IN: privately published, 2001.

Palmer, Louis J., Jr. *Encyclopedia of Capital Punishment in the United States*. 2nd ed. Jefferson, NC: McFarland and Company, 2008.

Patterson, Edna B., Louise A. Ulph and Victor Goodwin. *Nevada's Northeast Frontier*. Reno: University of Nevada Press, 1991.

Peckham, Howard H. *Indiana: A History*. Champaign: University of Illinois Press, 2003.

Reid, John B., and Ronald M. James. *Uncovering Nevada's Past: A Primary Source History of the Silver State*. Reno: University of Nevada Press, 2004.

Riddle, Jennifer C., Sena M. Loyd, Stacy L. Branham and Curt Thomas. *Nevada State Prison*. Charleston, SC: Arcadia Publishing, 2012.

Wines, Claudia, with the Northeastern Nevada Museum. *Elko County, Nevada*. Charleston, SC: Arcadia Publishing, 2008.

Magazines

Butterfield, Roger. "Elko County." *Life*, April 18, 1949.

"The Cat with the Amber Ring." *Actual Detective*, June 1943.

Newspapers

Carson City Chronicle, April 30, 1943; September 22, 1944.

Elko Daily Free Press, August 21, 1942; August 24, 1942; August 27, 1942; September 22, 1942; September 28, 1942; September 29, 1942; September 30, 1942; October 5, 1942; November 30, 1942; November 15, 1943; November 17, 1943; November 30, 1943; December 14, 1943; September 8, 1944; September 29, 1944.

Elko Independent, September 9, 1935; September 11, 1935; September 28, 1944.

Lafayette Journal Courier June 15, 1930; September 30, 1944.

Lafayette Leader, June 20, 1930.

Mulberry Reporter, October 6, 1944.

Nevada State Journal, December 15, 1943; January 11, 1944; June 18, 1944; September 27, 1944; September 29, 1944; September 30, 1944.

Reno Evening Gazette August 22, 1942; September 27, 1944; September 30, 1944.

Reno Gazette Journal, April 21, 1943.

CORRESPONDENCE

The following letters, as well as various Western Union telegrams, were found in the Nevada State Library or Oliver Custer's case files for the Floyd Loveless case.

Bible, Alan, attorney general of the State of Nevada, to George F. Wright, district attorney of Elko, Nevada, June 18, 1944.

Bible, Alan, deputy attorney general of the State of Nevada, to Oliver Custer, November 30, 1942.

Blakely, Mary Catherine, Nevada State Welfare Department Division of Child Welfare Services, to Oliver Custer, 1942.

Bottolfsen, C.A., governor of Idaho, to E.P. Carville, governor of Nevada, August 29, 1944.

Boucher, Milton, to E.P. Carville, September 23, 1944.

Brodigan, Margaret, clerk of the Supreme Court, to Mae E. Caine, county clerk of Elko, Nevada, September 1, 1944.

Brodigan, Margaret, to Oliver Custer, October 1, 1944.

Busher, Frederick H., reverend, to E.P. Carville, September 16, 1944.

Carville, E.P., to C.A. Bottolfsen, September 6, 1944.

Carville, E.P., to E.J. Flanagan, reverend, July 14, 1944.

Carville, E.P., to Frederick H. Busher, September 21, 1944.

Carville, E.P., to Lawrence W. Thompson, November 28, 1942.

Carville, E.P., to Milton Boucher, October 13, 1944.

Carville, E.P., to Mrs. Grace Taylor, October 14, 1942.

Carville, E.P., to Mrs. K.R. Whitney, January 2, 1944; October 2, 1944.

Carville, E.P., to Mrs. Len Loveless, various letters, 1942–44.

Carville, E.P., to Theodore E. Miller, reverend, October 15, 1942.

Custer, Oliver, to Mary Catherine Blakely, November 18, 1942.

Custer, Oliver, to Mrs. Ed White, November 9, 1944.

Custer, Oliver, to Ralph G. Wales, November 30, 1942.

Custer, Oliver, to Richard Sheehy, warden of Nevada State Prison, November 18, 1942.

Custer, Oliver, to Taylor H. Wines, various letters, 1943–44

Findley, Mrs. Laura Belle, Mrs. Mae Huddleston and Mrs. Len Loveless to E.P. Carville, October 17, 1942.

Flanagan, E.J., to E.P. Carville, July 11, 1944.

Hawkins, L.O., telegram to E.P. Carville, chairman of the Board of Pardons and Paroles, September 25, 1944.

Hawkins, L.O., to Board of Pardons and Paroles, September 18, 1944.

Hawkins, L.O., to E.P. Carville, September 18, 1944.

Hawkins, L.O., to Mrs. Ed White, July 21, 1944.

Hawkins, L.O., to Oliver Custer, November 27, 1942.

Keller, Harry, editor of Detective Stories Publishing Company, to Richard Sheehy, November 2, 1942.

Loveless, Floyd Burton, to Frank B. Robinson, August 18, 1944.

Loveless, Floyd Burton, to Mrs. Ed White, various letters, 1942–44.

Loveless, Floyd Burton, to Mrs. K.R. Whitney, various letters, 1943–44.

Loveless, Floyd Burton, to Oliver Custer, various letters, 1943–44.

Loveless, Mike, to the author, various letters, 2010–16.

Loveless, Mrs. Len, to E.P. Carville, various letters, 1942–44.

Loveless, Mrs. Len, to Oliver Custer, 1942.

Loveless, Mrs. Len, to Richard Sheehy, various letters, 1942–44

Loveless, R.C., telegram to Richard Sheehy September 30, 1944.

Loveless, R.C., telegram to Warden Carson City Penitentiary, September 29, 1944, 10:56 p.m.

Loveless, Robert Kay, to the author, 1987.

Loveless, Robert Kay, to the author, 1986.

MacCaffrey, J.C., to Mrs. Len Loveless, October 9, 1942.

McDonald, James, lieutenant of the Identification Bureau of the City of Lafayette, Indiana Department of Police, to George F. Wright, September 18, 1944.

Miller, Theodore E., reverend to E.P. Carville, October 7, 1942.

Morgan, Thelma Brooks, to the author, 2002.

Parks, Lucille Snider, secretary to Oliver Custer, office memo to Governor Carville, n.d.

Parks, Lucille Snider, to Taylor Wines, 1944.

Robinson, Frank B., to E.P. Carville, August 28, 1944.

Rowe, E.R., to Richard Sheehy, October 9, 1942.

Sheehy, Richard, telegram to R.C. Loveless, September 29, 1944.

Sheehy, Richard, to Honorable James Dysart, October 7, 1942.

Sheehy, Richard, to Mrs. Len Loveless, various letters, 1942–44.

Sheehy, Richard, to Ray C. Loveless, October 2, 1944.

Taylor, Mrs. Grace, to E.P. Carville, October 6, 1942.

Taylor, Mrs. Grace, to Richard Sheehy, October 7, 1942.

Thompson, Lawrence W., to E.P. Carville, November 24, 1942.

Wainwright, J.W., U.S. probation officer, to Richard Sheehy, November 5, 1942.

Wales, Ralph G., National Probation Association 110, telegram to Oliver Custer, November 17, 1942.

White, Mrs. Ed, to L.O. Hawkins, July 12, 1944.

White, Mrs. Ed, to Oliver Custer, January 2, 1946.

White, Mrs. Ed, to Richard Sheehy, October 1, 1944.

Whitney, Mrs. K.R., to E.P. Carville, December 30, 1943.

Wines, Taylor H., telegram to Oliver C. Custer, September 18, 1944.

Wines, Taylor H., to Lucille Snider Parks, 1944.

Wines, Taylor H., to Oliver Custer, various letters, 1943–44.
Wright, George F., to Honorable Supreme Court of the State of Nevada, July 6, 1944.

INTERVIEWS

Custer, Oliver C. Interview by Diane Carlson Grulke, 1985.
Loveless, Dorothy. Interview by the author, 1985.
Loveless, Mike. Interview by the author, 2016.
Loveless, Robert Kay. Interview by the author, 1985.
Morgan, Thelma Brooks. Interview by the author, 2002 and 2016.
Woods, Peggy. Interview by Lisa Seymour, Northeastern Nevada Museum, 1994.

OTHER

Bible, Allen. "Recollection of a Nevada Native Son: The Law, Politics, the Nevada Attorney General's Office, and the United States Senate." Interview by Mary Ellen Glass, 1977–78. Oral History No. 95, E748.B49, 1982. University of Nevada Oral History Archive.
Court Order. July 10, 1942. Indiana Tippecanoe County Juvenile Court.
Court Order. Warrant of Execution, October 5, 1942, No. 1362, Fourth Judicial Court State of Nevada, Elko County.
Curtis R. Loveless–Hazel Belle Frey. Clinton County, Indiana Marriage records. Page 28 BK PG 16-592.
"The Evidence Will Not Support a Conviction of First Degree Murder." Oliver Custer and Taylor Wines's work notes. File containing Oliver Custer's and Taylor Wines's work pertaining to Floyd B. Loveless case. Among these items are notes and correspondence and several legal papers.
Appellant's Opening Brief Statement of Fact No. 3410 Nevada Supreme Court.
Application for commutation of sentence to the Board of Pardons, Carson City, Nevada. Signed by Floyd Burton Loveless. September 11, 1944.
Dr. G.H. Ross timeline record of the execution (death) of Floyd Burton Loveless. September 29, 1944.
Receipt dated December 28, 1943. Signed by Oliver Custer, acknowledging cash donations from individuals, local unions and clubs (casinos) for representing Floyd Loveless in Supreme Court of Nevada.
Floyd Burton Loveless. Local Record of Birth Book S-9 Page No. 47. Tippecanoe County Department of Health, Lafayette, Indiana.
Floyd Burton Loveless confession. Dated July 6, 1942, Lafayette, Indiana.

Goldbeck, Willis, director. *Johnny Holiday*. United Artists, 1950.

Incoming/Outgoing Mail file 4606, 1943. Inmate file of Floyd Burton Loveless. Nevada State Library, Archives and Public Records, Carson City.

"In the Matter of Application of Giro L. Mei, also known as Jerry May, by Josephine May, in his behalf for a Writ of Habeas Corpus." Giro L Mei case. New Jersey Court of Errors and Appeals. 186 A. 577, 121 N.J. Eq. 123.

Loveless, Floyd Burton. Prison Health Record. Floyd Burton Loveless inmate file at Nevada State Library, Archives and Public Records Carson City, Nevada

Loveless v. State. 62, Nev. 17, 136 P. 2d, 236 (1943).

Loveless v. State. 62, Nev. 312, 130 P. 2d, 1015 (1944).

Nevada Capital Punishment History. cncpunishment.com.

Nevada State Prison Inmate Case Files: Floyd Burton Loveless. Nevada State Library, Archives and Public Records, Carson City.

"Official Opinion of the Attorney General." Nevada Office of the Attorney General (Alan Bible), 1944. Nevada Reports 1943–1945 (62 Nev.). Printed by the State of Nevada.

"100 Years of Indiana Boys' School 1867–1967." Souvenir book. Parole and Pardons Board Minutes, n.d.

Petition for withdrawal of money submitted by John Frey. Tippecanoe Circuit Court, January 1933.

"Proposed Draft for a Standard Juvenile Court Act with changes approved at the Committee meeting October 9, 1942 National Probation Association." Petitioner Appellant Brief of Amici Curiae. Submitted October Term 1936. Charles E. Hughes Jr., president, National Probation Association.

Rocha, Guy. "An Outline of Capital Punishment in Nevada." Article at Nevada State Library, Archives and Public Records, Carson City.

"Seventy-Eighth Annual Report of the Indiana Boys' School Plainfield." June 30, 1944.

"Seventy-Fifth Annual Report of the Indiana Boys' School Plainfield." June 30, 1941.

"Seventy-Seventh Annual Report of the Indiana Boys' School Plainfield." June 30, 1943.